WIDE **SKIES**

A CENTURY OF PAINTING AND PAINTERS IN NORFOLK

WIDE **SKIES**

A CENTURY OF PAINTING AND PAINTERS IN NORFOLK

Adrienne May and Brian Watts

HALSGROVE

Published in association with the
Norfolk and Norwich Art Circle

First published in Great Britain in 2003

British Library Cataloguing-in-Publication Data
A CIP record for this title is available from the British Library

ISBN: 1 84114 297 2

HALSGROVE
PUBLISHING, MEDIA AND DISTRIBUTION

Halsgrove House
Lower Moor Way
Tiverton, Devon EX16 6SS
Tel: 01884 243242
Fax: 01884 243325
email sales@halsgrove.com
website www.halsgrove.com

Printed by D'Auria Industrie Grafiche Spa, Italy

Foreword

by
CAVENDISH MORTON R.I. Hon RO.I.

I feel very privileged to have been asked to write a foreword to Wide Skies, an extensively revised and updated edition of the Norfolk and Norwich Art Circle Catalogue and History, first published in 1985. The two volumes together form an extremely valuable record of the work of the members of this vigorous society. Congratulations are due to all those who worked on the production of this splendid volume. The addition of colour plates is extremely pleasing.

Now in my 93rd year many memories come to mind. I first saw the work of Arnesby Brown in the middle of the nineteen twenties at the Royal Academy. I admired the way he seemed to capture the very essence of the English countryside as it was nearly eighty years ago. In 1951 I arranged for the Festival of Britain an exhibition in Eye, which L.S. Lowry visited and, on seeing an oil by Arnesby Brown, he turned to me and said 'Look at that brushwork, isn't it marvellous.' The style of painting could hardly be more different from his own but it was revealing to see the admiration he had for technical brilliance.

Alfred Munnings was a great character of the Circle. He had a strong dislike of modern paintings. I remember getting into some difficulty when he generously offered to loan me some of his works, I think it was for a charity exhibition in aid of Hungarian Relief. I drove down to Dedham and after tea he chose some works for me, but before I left he said 'You aren't hanging any of those damned moderns'. I had to admit I had paintings that he might have disapproved of. After a rather tense half hour I finally satisfied his susceptibilities by assuring him that they would be hanging in a separate room.

My most lasting memory is of the vitality of the members' works and the exchange of ideas, all so stimulating. Back in the Isle of Wight for the past twenty-five years, I still miss the brilliance of the light of East Anglia.

Bembridge 2003

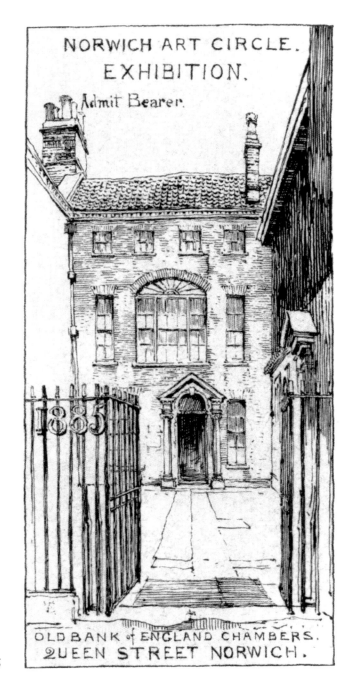

Invitation card 1885

Contents

Acknowledgements

The subcommittee, Brian Watts, Chairman 2002–3, Adrienne May, Chairman 2003–4 and Ray Banger, now Honorary Treasurer, formerly Honorary Secretary and prime mover in 1985, acknowledge the hard work of all those involved in the Centennial Exhibition and catalogue. In particular they thank Joan Banger in her capacity as NNAC archivist, Marianne Downing, Michael Everitt and Norma Watt of Norwich Castle Museum and Art Gallery for her enthusiatic support and cooperation. They also thank all those past and present members who have assisted with advice and information.

The authors would also like to thank the following for their assistance in the collection of material for this publication:

Abbott & Holder Co. Ltd, 30 Museum Street, London

The Bishop of Norwich, the Rt Revd Graham James, Bishop's House, Norwich

Browse & Darby, 19 Cork Street, London

Ipswich Borough Council Museum and Galleries, High Street, Ipswich

Judy Hines Art Gallery, Fish Hill, Holt, Norfolk

Keys Fine Art Auctioneers, Aylsham, Norfolk

Llewellyn Alexander Ltd, 124–126 The Cut, Waterloo, London

Norwich Castle Museum and Art Gallery, Castle Meadow, Norwich

The Sir Alfred Munnings Art Museum, Castle House, Dedham, Essex

Trustees of the Estate of Edward Seago, courtesy of Thomas Gibson Fine Art

Westcliffe Gallery, 2–8 Augusta Street, Sheringham, Norfolk

NOTES AND ABBREVIATIONS

Measurements of paintings are in centimetres: height × width for pictures, height × width × depth for sculptures.

EDP – *Eastern Daily Press* newspaper

INSC – Inscriptions in the artist's hand

EXH – Exhibitions. Only Norfolk and Norwich Art Circle (NAC) and Woodpecker Art Club (WAC) exhibitions are given.

IFAC – Ipswich Fine Art Club

NEAC – New English Art Club

RA – Royal Academy

RBA – Royal Society of British Artists

RE – Royal Society of Painter-Etchers and Engravers

RI – Royal Institute of Painters in Watercolours

ROI – Royal Institute of Oil Painters

RWS – Royal Society of Painters in Watercolours

SWA – Society of Women Artists

Introduction

The origins of *Wide Skies*, a History of the Norfolk and Norwich Art Circle

This illustrated history of an important art society is an extensively revised and updated work based on the catalogue of the Centennial Exhibition, 1985.

It was at the NNAC 2001 summer exhibition in Norwich Cathedral, that Simon Butler of Halsgrove became interested in the Circle. The potted history included in the exhibition catalogue caught his eye and he made contact with Joan Banger, the Circle's archivist. As a result, Naomi Cudmore and Sadie Butler, both employees of Halsgrove, were asked to attend an NNAC council meeting on 28th November 2001. In truth, most councillors were quite in the dark about the purpose of Naomi and Sadie's visit, and they were I fear, listened to with some degree of scepticism.

It was agreed that a special meeting would be held on 14th January 2002 to discuss the possibility of a volume based on the Centennial Catalogue. At that meeting, Brian Watts was proposed as chairman of a subcommittee to further examine the possibilities, with the power to appoint the other members. Brian asked Adrienne May to join the committee and later Ray Banger, now Hon. Treasurer, joined.

At the next meeting of the NNAC Council in March, it was provisionally decided that the sub-committee should proceed on its own terms, with the power to select artists who would feature. The only criteria for selection would be success as an artist in the national perspective. At the AGM in May 2002, the subcommittee received the backing of the meeting to proceed with this exciting new project.

Adrienne May
Brian Watts
Norwich 2003

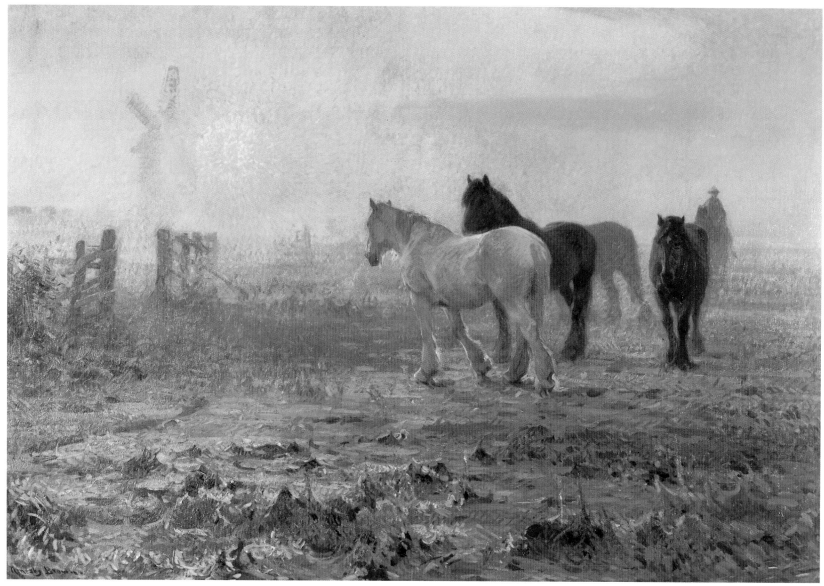

The Coming Day
(Arnesby Brown)
Oil on canvas (121.3 x 177.5)
Norwich Castle Museum and Art Gallery

A History of the
Norfolk and Norwich Art Circle

The formation of the Norwich Art Circle in 1885 followed a great tradition of art in the city. Norwich has not only produced many artists who have achieved national and international recognition, but also the first major provincial school of artists in the country. As early as the eighteenth century there was much artistic activity in the city with professional artists and craftsmen. Most significant were the portrait painters who received commissions from the local gentry and aristocracy as well as from an enlightened City Council that commissioned portraits of its civic leaders. Norfolk also attracted many eminent visiting artists from London who found patrons among the wealthy landowners in the county or came simply in search of the picturesque.

The turn of the century saw an even greater burgeoning of artistic life in Norwich. There was a thriving community of professional artists, drawing masters, scene painters, sign and heraldic painters, framers and gilders and print sellers, as well as the collectors and patrons who supported them. This culminated with the founding of the Norwich Society of Artists in 1803. John Crome (1768–1821) is regarded as the founder, and John Sell Cotman (1782–1842) joined four years later. Crome gained national recognition as a major landscape painter who had a profound influence on succeeding generations of artists, and Cotman as one of Britain's finest watercolour painters.

The Norwich Society of Artists was the earliest provincial group of artists to exhibit their work. The Society survived for over thirty years, despite an attempt to form a breakaway group in 1816, and covered three generations of artists. The membership comprised well-known families of Norwich artists, their pupils and friends. The Society met fortnightly to discuss art and in 1805 began its annual exhibitions. It ceased in 1833, partly because of a lack of patronage due to economic recession, but also because some of the leading members had either died or left Norwich. Nevertheless, from it had grown the Norwich School of Artists, a major provincial school of landscape artists which forged an important place in the history of British Art.

Art in Norwich now took a new direction. Several of the later generation of Norwich School artists campaigned with John Barwell, a wine merchant and former secretary of the old Norwich Society of Artists, and his wife Louisa to establish a School of Design in Norwich. Eventually they succeeded and the Norwich Government School of Design opened its doors to pupils in 1846, its principal aim being to improve industrial design. Financed by the Board of Trade, provincial Schools of Design had been set up to train artisans to design for industry. In common with other provincial schools, Norwich never actually achieved this aim. The pupils that it later attracted were not the artisans, but essentially middle-class, many of them women, interested more in the fine arts than in design for commerce. The School did, however, become the training ground for many of the artists who later formed the Norwich Art Circle. Inevitably, throughout its history the Norwich Art Circle was to have strong links with the School of Art, and the Barwell family was to continue to play an important role in both.

Since the demise of the Norwich Society of Artists, various attempts had been made to hold regular exhibitions in Norwich. For example: the Norfolk and Norwich Art Union Exhibition 1839; the Norwich Polytechnic Exhibition 1840; the exhibitions of the Norfolk and Norwich Fine Arts Association 1848–71; and various other loan exhibitions. Towards the end of the century artists in Norwich were very conscious of the need to bring together professional and amateur artists as well as members of the public interested in the arts, and so in the early weeks of January 1885, at the studio of Charles John Watson at All Saints Green, three artists discussed the possibility of forming a new society in Norwich. C.J. Watson and his two friends, Edward Elliot and Robert Bagge Scott, later held a meeting in February at the home of Charles Clowes on Carrow Hill to discuss the details of forming such a society. They drew up a list of Rules (see page 115) and decided that there should be a President, Vice-President, Treasurer and Secretary. The annual subscription was to be one guinea and an exhibition would be held annually. The new society was to be known as the Norwich Art Circle. Thus the Norwich Art Circle was born under the leadership of C.J. Watson as President, Robert Bagge Scott as Vice-President, Henry George Barwell as Treasurer and Leonard Bolingbroke as Secretary.

The newly-formed society searched the city for suitable premises and eventually decided on a room at Old Bank of England Chambers, Queen Street. The landlord, a Mr Cooper, was approached and arrangements for its hire concluded. The rent for the room was £15 per annum and the cost of decoration was £12.14s.11d. In addition £18 was spent on furniture. The caretaker's salary for thirty-six weeks was six guineas, and for the first year gas and coal cost £1.13s.1d.

Fye Bridge, Norwich
(C.J. Watson)
1885 pencil and watercolour (40.6 x 32) INSC: left
centre edge C. J. Watson/1885 EXH: NAC 1885 (3)
Norwich Castle Museum and Art Gallery, R. J. Colman
Bequest 1946 (1378–235.951)

The first General Meeting of the new society was held on 23rd April 1885 when the Council outlined its plans to the members. It announced that the premises would be open to members at all times and members could, if they wished, purchase a key. Catalogues of principal art exhibitions would be left out in the room and copies of journals such as *Portfolio*, *L'Art* and *Gazette des Beaux Arts* would also be available. Although the expense of these periodicals was considerable, the Council felt that the chance to read some of the best art publications of the day would be an irresistible attraction to new members. The walls of the room were to be hung with members' work, except when the space was needed for annual exhibitions, and the Council hoped it might be possible to have on loan examples of the work of eminent artists. During the winter months it was planned to hold *conversaziones* and it was further proposed to issue an art publication with contributions by members.

The Art Circle started with a membership of thirty-six. Members from several well-known Norwich families were included: Barwell, Boardman, Bolingbroke, Colman and Jarrold. Not all were practising artists. For example, of the forty-six members belonging to the Art Circle at the time of the first exhibition in September 1885, twenty-five never exhibited. They were, however, lovers and collectors of art, and their patronage was invaluable. Not only did they assist the Art Circle financially, but lent pictures from their own collections to members' meetings and to the special Historical Exhibitions.

On 12th September 1885 the Norwich Art Circle staged its first exhibition at its clubroom. An invitation card (see *frontispiece*) depicting the premises at Old Bank of England Chambers was designed and an impressive catalogue produced. The press previewed the exhibition and voiced the aims of the new society: 'It is hoped that the movement may revive in Norwich some of the old feeling for art for which we were once celebrated.' (EDP [*Eastern Daily Press*], 12th September 1885). The forty-six oils and watercolours included in the exhibition were contributed by fourteen members. Sales amounted to £100 of which the Art Circle received 7½ per cent in commission. The exhibition was visited by a vast number of people who thronged into the limited space of the clubroom, curious to see what the new society was about. Originally admission to the exhibitions was by a ticket obtainable from a member or from the attendant at the clubroom, but by September 1887 it was decided to allow the general public in without restriction.

Although the first exhibition was probably regarded as a popular success, its reception from the press was fairly muted. The *Norfolk Weekly Standard* (14th September 1885) reported that 'The Society has

made a fair start' and that the exhibition included 'a few score of very creditable pictures'. However, they went on to criticise a watercolour by Miss C.M. Nichols as '...a hard if not hideous smudge', although they considered the rest of her exhibits successful, and thought that 'in one or two instances passable pictures are spoilt by atrocious frames'. There was nevertheless a general desire for the new Art Circle to succeed: 'Lovers of art will, we are sure, desire to give encouragement to the Norwich Art Circle, which is nobly striving to revive the fame of the Norwich School of Painters.' (EDP, 14th September 1885).

Their praise for the catalogue, however, was unanimous. A limited edition of about 200 was printed on handmade paper by Fletcher & Son, whose Chairman, B.E. Fletcher, was a member of the Art Circle. The catalogue was illustrated by autolithographic facsimiles, which were the first of their kind ever produced in Norwich. It was quickly sold out and made a small profit for the Art Circle. The catalogues continued to be produced in this format until 1899.

The second exhibition was held in January 1886 and consisted entirely of black and white works. All mediums were included: oil, watercolour, pen and ink, pencil, charcoal and etching. Doubts had been expressed about the wisdom of holding black and white exhibitions. It was felt that they would be of little interest to the public, but they do appear to have been very successful: 'There are few provincial art societies that can produce enough black and white work year by year to warrant a separate display. The Norwich Circle is among the foremost of them, and its old reputation for excellence in that department is still well maintained.' (EDP, 20th May 1901). The Black and White exhibitions were held annually until 1913, alternating with the Oil and Watercolour Exhibitions.

The *conversaziones* which opened the Black and White Exhibitions became an important social event. Two adjoining rooms to the clubroom had been hired, which for the exhibition in 1888 'were luxuriously furnished for the occasion, and everything that could tend to the comfort and enjoyment of the guests was thoughtfully provided…' (*Norfolk Chronicle*, 21st January 1888). The rooms, two of which were hung with pictures while in the third a buffet was served, were furnished with 'A tasteful coloured square carpet… bordered in each room by a wide strip of crimson cloth, and the wide windows draped with tinted lace curtains.' (*Norwich Mercury*, 19th January 1887). The invited guests in evening dress began arriving at 8p.m.. The most important was usually J.J. Colman MP, a member of the Art Circle, who was accompanied by several members of his family. All the leading Art Circle members were there as well as several Norwich businessmen and their families.

Title page of the October 1896 Art Circle Exhibition Catalogue

They were entertained with a programme of music and singing, organised by Miss Louisa Barwell who was also one of the singers and who regaled the audience with such songs as 'When the Elves'. 'Many must have felt the somewhat magic charm of the Art Circle opening on reaching it through the rather prosaic, not to say vulgar associations of Norwich streets on a Saturday night.' (*Eastern Evening News*, 16th January 1888).

An important aspect of the work of the Norwich Art Circle in the early years was the series of Historical Exhibitions, major loan exhibitions of the work of eminent Norwich School artists. These were largely due to James Reeve. A former student of the School of Art, Reeve became Curator of the Norwich Museum at the age of eighteen. He had a lifelong interest in the Norwich School of Artists and advised the Colman family on which pictures to purchase for their magnificent collection which was later bequeathed to Norwich Castle Museum.

The first of these Historical Exhibitions was devoted to the work of John Thirtle (July 1886), followed by James Stark (June 1887), John Sell Cotman (July 1888) and the Revd Edward Thomas Daniell (July 1891). Pictures were lent by James Reeve himself and by several other local collectors including J.J. Colman, H.G. Barwell and the Bolingbroke family. The exhibitions were very popular and received much critical acclaim, both locally and outside Norwich. The Cotman exhibition was later shown in London at the Burlington Fine Art Club.

To accompany the Historical Exhibitions the Art Circle produced detailed catalogues, all of which have been an important source of information for researchers on the Norwich School. Perhaps the Cotman catalogue should be singled out, because at a time when catalogues were often merely lists of pictures, this one was packed with information and was the first publication of any real substance devoted to Cotman. It contained lists of exhibited works, biographical details and descriptions of the pictures as well as facsimile illustrations, and even in 1888 cost £2. It undoubtedly came about through the farsighted approach of James Reeve who spent a lifetime amassing valuable information on the Norwich School, laying the foundations for all future research. The press too recognised the value of this work: 'In bringing together these pictures and procuring for the public the advantage of enjoying them, the Norwich Art Circle has more than justified its existence, while in producing the magnificent catalogue containing a well written life of Cotman, with lists of his works and a number of illustrations, they have accomplished a task, the use of which is not confined to today but will be felt more fully in years to come.' (EDP, 2nd August 1888).

In addition to the Historical Exhibitions, the Art Circle would occasionally include in its annual exhibitions small collections of topographical views of Norwich or prints and drawings by Norwich School artists from members' own collections.

The evening meetings which took place in the winter months in the clubroom were very lively affairs, sometimes accompanied with music and singing superintended by the redoubtable Miss Barwell. These social meetings for members and friends were held on the first Monday of each month. Members would read papers on different aspects of art, or the work of distinguished living artists was borrowed and discussed. Meetings on prints and modern printmaking processes also proved to be popular. Impromptu sketching meetings took place on Wednesdays when members illustrated a subject selected by the President of the evening, while on Mondays and Fridays J. Miller Marshall held a life class. The work resulting from these classes was exhibited and discussed at later meetings. They were also interested in decorative art. Small collections of modern pottery and glass, early needlework, metalwork or carvings were assembled in the clubroom for members to inspect. On occasion these collections were opened to the public.

Despite the full use made of the clubroom by the members, when the tenancy expired in 1895 the Council felt that the rooms were no longer suitable for the exhibitions. Indeed in the view of the press '...a more dismal spot for a picture gallery it would be hard to find. Into two out of three of the rooms sunlight has never entered since the premises were built. In such surroundings even a Cotman or a Crome would find it hard to look cheerful.' (EDP, 21st October 1892). It was, therefore, agreed that improved accommodation should be found and so, after ten years in Old Bank of England Chambers, the Art Circle gave up its clubroom, the focal point of all its activities, placed the furniture in a store over Mr Barwell's office, and instead hired St Peter's Hall, Upper Market, twice a year for exhibitions.

Presumably another reason for not renewing the tenancy or finding other permanent premises was financial. In the 1895 Report the Council appealed to all art lovers to support the Art Circle to enable it to carry on its activities. Its only source of income was from subscriptions and commission on the sale of paintings, which was usually very small. For example in 1895 it was 17s.11d., with £63 received from subscriptions. The cost of running the clubroom had over the years increased, and by 1894, the last full year in the clubroom, the financial statement showed a balance of only 5s.5d. As a result of the move and the loss to members of the clubroom facilities, the subscription for exhibitors was reduced to half a guinea and no commission charged on sales.

Without a permanent base the activities of the Art Circle were curtailed. Costs were certainly reduced, but there were no more Historical Exhibitions, no more musical soirées, and consequently they no longer needed to hire a piano or pay for 'professional musical assistance'. This was the end of a very colourful and lively period of the Art Circle. Attempts were made, however, to retain a sense of occasion at the openings at St Peter's Hall. These were held in the afternoons, when tea was served by the ladies, and the hall was decorated with a brown paper dado and palms.

With the Art Circle in a less precarious financial position and with an increased membership, the Council reported in 1896 that they felt confident of the future. But the Art Circle seemed to have lost some of its impetus. The local press implied that their exhibitions had become stale and, although it maintained its level of steady conscientious work, it did 'not enlarge its borders or attract much fresh ability to its walls' (EDP, 12th May 1896). Then in October 1896 the Art Circle exhibition received its most damning review. The hanging committee was criticised for not being selective: '. . . there were pictures (which may be identified without the slightest assistance) that ought never to have been sent to any exhibition, or that ought to have been unhesitatingly rejected if they had been sent. And further, many of the pictures from not a few of the better known artists show an unfortunate deterioration.' (EDP, 6th October 1896).

Criticism and controversy were not new to the Art Circle. In 1891 the EDP critic wrote that he could not 'help being struck with an element in the exhibition that can hardly find favour with visitors. During the last few years two phases of art have largely influenced English students. We refer to the French School and the Impressionist movement... they both contain elements which have brought upon them much ridicule and censure. A glance round the rooms in Queen Street will show that Norwich has not altogether escaped.' (17th October 1891). He singled out the work of Miss C.M. Nichols and H.E.J. Browne, and criticised them for not taking art seriously. He went on to say that Miss Nichols was capable of doing good work but that these particular canvases were not suitable for public exhibition. 'If such a society is to be useful and retain its reputation, it is surely the duty of members to contribute nothing but sterling work to its exhibitions, or work at least that shows earnestness of purpose.'

Needless to say the formidable Miss Nichols immediately wrote a protesting letter to the press. Most interestingly she blamed the unimaginative teaching methods in the Government Schools of Design as the reason that forced artists to seek new ideas from abroad: 'The truth is, your critic lets it escape

that he is piqued at English artists deserting England for more congenial soil. France is the home of the artist; England has driven away her sons to Paris and Antwerp by her evident incapacity for teaching. South Kensington's cut-and-dried proceedings don't somehow attract the artistic soul; hence the defaulting.' (EDP, 23rd October 1891). She went on to question the critic's capability and accused him of lack of discernment. The press replied 'What an excitement has been occasioned among the members of the Norwich Art Circle by a little bit of honest criticism!' (24th October 1891).

In 1898 the Art Circle lost a valued founder member with the death of H.G. Barwell, 'their best friend and most generous patron of art' (1899 Report). He had been their President for at least ten years and in recognition of this a small commemorative exhibition of his work was shown at the 1899 exhibition. He was one of the five sons of John and Louisa Barwell, who were instrumental in the establishment of the School of Design in Norwich, and he was himself Secretary of the School for twenty-five years. His brother Frederick Bacon Barwell (1830–1922), a distinguished artist of his time and exhibiting member with the Art Circle, was instrumental in persuading the City Council to take over responsibility for the School of Art (of which he had once been a pupil) and in 1899 it became part of the Norwich Technical Institute in a new building in St George's Street, where it is still housed.

There was a small coterie of members connected with the School of Art at this time. The Headmaster, Joseph Woodhouse Stubbs, had been a founder member but did not exhibit, and his successor Walter Scott was also a member for several years, although exhibiting only once. Miss C.M. Nichols had been a pupil for a brief two terms, and three other ladies, all pupils of Stubbs, distinguished themselves by winning various awards. They were Ethel Buckingham (later Mrs Charles Havers), Margaret Holmes and Gertrude Offord; all exhibited with the Art Circle.

The attention given by the press to the work of the women members and the prominent role they played gives the impression that they far outnumbered the men. However, of the 1,211 exhibiting members throughout the history of the Art Circle up to 2003, 654 were women, and so numbers were fairly equally divided. There were, however, an exceptional number of talented women artists among the members, reflecting the general trend in the second half of the nineteenth century when women artists began to emerge from their previous obscurity. More women were attending art schools, frequently winning most of the prizes, as well as exhibiting their pictures for the first time and demonstrating that they were equally talented.

Perhaps the most famous Art Circle member and pupil of the School of Art was Alfred Munnings. He made his debut with the Art Circle in 1897 at the age of nineteen: 'Not for some years have the walls been so well covered… there are a few new comers, who are in themselves a tower of strength. Chief among these latter are Mr A.J. Munnings, who is allotted, and deservedly so, no fewer than thirteen places, nine of his pictures being in watercolour and the rest in oils. Whatever he does is obviously the fruit of a singular facility. Mr Munnings, we believe, is not yet out of his teens, and the Norwich Art School, where he is a student may consider itself entitled to some degree of credit on his account... An inborn facility, and not an acquired dexterity is his distinguishing mark… We hope to hear more of Mr Munnings.' (EDP, 11th October 1897). And indeed much more was heard of Mr Munnings.

The following year, 1898, St Peter's Hall was not available for the Oil and Watercolour Exhibition and so an upper room was hired in the Bank Plain Assembly Rooms. It was well lit and more spacious and, despite being on the top floor, over a thousand people attended the Private View. The increased space enabled the Art Circle to hold its largest exhibition of 132 pictures, a figure not surpassed until 2003 when 141 exhibits were shown. Seventy was the previous average, and less for the Black and White Exhibitions.

In Art Circle exhibitions, watercolours predominated and inevitably topographical views of Norwich and Norfolk were favourite subjects, as well as pictures made during holidays. There was a profusion of flower paintings, mainly by the ladies, such as Fanny Jane Bayfield, Lucy Finch, the Offord sisters and Ethel Buckingham. The Black and White Exhibitions produced an interesting assortment of subjects, some of the more unusual being graphic designs for such things as book covers, menus, posters and book plates. Alice B. Woodward and Sidney Felix Howitt were the main contributors of these, both very skilled professional illustrators. It is probable also that the black and white watercolours which Munnings favoured in his early career were painted specially for the Black and White Exhibitions. Many years later, when he was President of the Royal Academy, he reminisced about these early exhibitions and their importance to him: 'The Norwich Art Circle was my goal from spring to spring, from autumn to autumn… All my efforts were made with the hope that I might shine there and perhaps sell my work… Norwich has its fine traditions in art and may the Art Circle carry them on always.' (EDP, 28th October 1946).

In 1899 the Art Circle lost three more prominent members. J.J. Colman, 'a most liberal patron of the Exhibitions' (1899 Report), died, and the original founder of the Art Circle, C.J. Watson and his wife

Minna Bolingbroke ceased exhibiting. Presumably they found that living in London since their marriage in 1894 made it increasingly difficult to take part in the activities of the Art Circle. They were both extremely able artists and skilful etchers and their work was always highly praised.

At the turn of the century the Council reported that the Art Circle had never been in so prosperous or so lively a condition. Each year membership was increasing and the exhibitions improving. Another Historical Exhibition was even contemplated, although this never took place. In October 1900 the format of the previously successful catalogue was changed. It was reduced in size by half and illustrated with photographic reproductions. An admission charge to the exhibition of 6d. (including a catalogue) was introduced for visitors, but this resulted in a drop in numbers to 450.

With the new century the Art Circle was by now a well-established part of the artistic life of Norwich. It was a relatively conservative group. New movements in art such as Cubism and Vorticism, and artists such as Kandinsky and Picasso were to have little effect on their art, and indeed its public did not wish to see change. In 1902 the EDP in its review of the fortieth Oil and Watercolour Exhibition wrote: 'The Art Circle at Norwich is now in the ripened years of middle life, for its exhibitions are in the forties. Middle age brings with it a certain tolerance of youthful crudities on which ground it may possibly be explained that [the exhibition] embraces several things that … would not have been admitted years ago.' (EDP, 27th October 1902). It went on to say that the Art Circle was not the place to exhibit experimental pictures and referred to one, a watercolour by Oliver Williams, which made the writer 'jib like a horse before a traction engine'.

At the outbreak of the First World War in 1914 it was decided to abandon the Black and White Exhibitions because of poor support. In view of the war the members also voted on whether to hold the autumn exhibition and only six voted against. The exhibition therefore took place and an illustrated catalogue was printed as usual, but inevitably the attendance was poor and very few catalogues sold. Nevertheless, an annual exhibition continued to be held throughout the war years. In 1918 the venue of the exhibition was changed again, this time to a room in the Free Library in Duke Street. It was well received by the EDP: '[the] best of them has never been bettered.' But it went on in a faintly admonishing tone: 'Curiously enough the war has exercised singularly little bias in the direction of military things and modes of feeling… the war might be "a trouble of ants" in another planet, so absorbed are the members in these pleasant ruralities, those studies of home, garden, antiquities, and so forth, which make the staple of an Art Circle show.' (7th September 1918). Conversely the

Norwich Mercury reported: 'With an enthusiasm that is commendable the Norwich Art Circle gives evidence of its determination to maintain its grip upon matters of art, notwithstanding the war and war's distractions. In this it is wise. The lamp of art may burn feebly in the disturbing atmosphere of war time but it is something that it is kept burning. And that is what the local Circle appears to be doing in its particular sphere of operations.' (14th September 1918).

At the end of the war in 1918 the Art Circle amalgamated the Oil and Watercolour and the Black and White Exhibitions into one annual exhibition which has continued ever since. In 1920 it also changed the method of selecting members. Previously prospective members were proposed by existing members, ballotted by the Council and elected. This was discontinued and instead it was only necessary for work to be submitted for inspection by the Council before election took place.

Unfortunately the Art Circle seemed to be declining after the war. Very few activities appear to have taken place, the minutes were virtually a brief repetitive rubber stamp from year to year with officers and council members automatically re-elected. Interest dwindled, so that by 1924 only two members attended the Annual General Meeting. In 1925, however, due to the death of the President, Robert Bagge Scott, the Art Circle was forced to look at its affairs and to consider its future.

Robert Bagge Scott had been the first Vice-President in 1885 and President since 1898. For thirty-nine years he had regularly exhibited his work and was a much admired and respected artist. Many of the leading members attended his funeral at St John Maddermarket, and fittingly his palette and brushes were placed on his coffin.

Four weeks later a special Council meeting of the Art Circle was held and after much discussion it was proposed that the Art Circle should indeed continue. No exhibition took place that year, but instead a memorial exhibition to Bagge Scott was held at the Castle Museum under the auspices of the Art Circle.

The new President was Geoffrey Birkbeck with Charles Hobbis as Vice-President. Several changes were made. Visitors no longer had to tramp up the steep stone stairway to the top of the Public Library to see the exhibition. Instead it was held 'in delightful quarters' at the Stuart Hall. Bagge Scott, who appears in the past to have constituted the hanging committee, had been criticised for being too lenient and accepting almost everything, but now the selection process had been tightened up consid-

erably, 'with the result that the average quality is of a higher standard than has been noticeable for some years past.' (EDP, 21st July 1926). The exhibition included a small selection of pictures from members' own collections, and for the first time sculpture was accepted. F. Maidie Buckingham, in 1985 the Art Circle's longest exhibiting member, was one of the contributors to this section. Advertising was included in the catalogue and a concert of music was also held, perhaps in an attempt to recapture some of the spirit of the early years of the Art Circle.

A sixteen-year-old member also made his first appearance with the Art Circle in this year. He was Edward Seago, who went on to become one of Norfolk's most admired twentieth-century artists. He had also exhibited with the Woodpecker Art Club earlier in the year, when the press, recognising his precocious talent, commented 'Mr Seago's ripening towards maturity will be well worth watching,' (EDP, 15th March 1926).

Anvil Cloud
(Edward Seago)
Oil on canvas (101.5 x 127) Norwich Castle Museum and Art Gallery. By kind permission of the Trustees of the Estate of Edward Seago. Courtesy of Thomas Gibson Fine Art

The Woodpecker Art Club, originally called the Woodpecker Sketch Club, was formed in about 1887 by Miller Smith, a founder member of the Art Circle, and five fellow wood engravers. The name derived from their mutual interest in wood engraving or wood 'pecking'. Catherine Maude Nichols was invited to be their first President. She was a remarkable woman. A writer, an intellectual, eccentric and bohemian, she was the driving force not only of the Woodpeckers but also of the Art Circle.

The Woodpeckers met socially and were interested in various cultural activities not necessarily connected with fine art. They held literary meetings, soirées and dramatic recitals as well as life classes and annual exhibitions of members' work. Their first premises were in City Chambers, Prince of Wales Road. The venue of their exhibitions changed several times, until finally they took place in the Castle Museum.

A merger between the Woodpecker Art Club and the Art Circle had been discussed at the special Council of the Art Circle in 1925. It seemed the logical course since both groups were pursuing the same aims and several artists belonged to both societies, but the proposal had been defeated. The idea was again mooted the following year by the Deputy Lord Mayor, Dr G.S. Pope, at the opening of the Woodpeckers' exhibition and members appeared to respond favourably. But it was not until November 1927 that Geoffrey Birkbeck, President of the Art Circle, and Nugent Monck, President of the Woodpeckers, met to discuss the amalgamation of the two societies. It was put to the Art Circle Council again in January 1928 and at last the union was formally agreed. A very successful social gathering was held on St Valentine's Day in 1928 to inaugurate the new joint society. The newly reconstituted society was known as the Norfolk and Norwich Art Circle (incorporating the Woodpecker Art Club). The distinguished Norfolk-based artist, Arnesby Brown, who had been an exhibiting member since 1916, was the President, while Geoffrey Birkbeck and Nugent Monck were Acting Presidents of the art section and literary section respectively. Nugent Monck, who had succeeded H.H. Prince Frederick Duleep Singh as President of the Woodpeckers, was actively involved in drama in the city and had founded the Maddermarket Theatre in 1921. As a consequence of the union the membership of the Art Circle increased dramatically from 82 in 1927 to 159 in 1928, despite many of the artists being members of both societies. The annual subscription was 12s.6d. for exhibiting members and 7s.6d. for non-exhibiting members connected with the literary section. The first exhibition of the new joint society took place in the Stuart Hall in June 1928 and appropriately it included a small commemorative exhibition of pictures by the first President and founder of the old Art Circle, Charles J. Watson, who had died in 1927.

Great efforts were made to popularise the exhibitions. Notices were placed in tramcars and publicity was discussed with the Norwich Publicity Association. Eminent people were invited to open the exhibitions which the Lord Mayor also frequently attended, and the press was encouraged to photograph the openings.

In 1931 a circulating portfolio of members' work was organised in order to develop interest in each others' experimental work. Unsigned work was placed in a portfolio and circulated amongst twenty or more members, each member criticising the work already in the folio and adding something of their own before passing it on. It took about three months to circulate and by the time it returned to each artist the comments of the whole group were added. This Portfolio Club, for many years organised by Ernest A. Curl and later by Henley Curl, continued through the war into the early 1950s. It eventually foundered when the portfolio became too bulky for the post and interest in it waned.

Another crisis developed in 1932 when the future of the Art Circle was once again in doubt. Geoffrey Birkbeck moved to London and so resigned the Presidency, and Charles Hobbis resigned from the Council. Charles Hobbis had been Headmaster of the School of Art since 1919 and was actively involved in the work of the Art Circle as Vice-Chairman. The Council therefore decided to appoint a subcommittee under the chairmanship of Ernest A. Curl to discuss the continuation of the Art Circle.

Eventually they produced a report which recommended that the Art Circle should continue, but that new rules and regulations should be drawn up for the reconstruction of the society. It was agreed that the President should be elected for a term of three years and that there should be nine Council members who served three years in rotation, and could only stand for re-election after the space of a year. The Council was to constitute the hanging committee and a majority of seven or more decided whether a member's work should be hung. Subscriptions were to be 7s.6d. and a Sketch Club was to be formed with a subscription of 3s. It was also decided to organise various lectures and suggestions were invited from members for other activities. They also decided to hold a competition to design a symbol for the Art Circle, and the well-known palette design first appeared on the 1932 catalogue. Significantly the venue of the exhibitions was also to be changed to the Castle Museum, and so began a long association with the museum and its staff.

It was a revitalised Art Circle that held its eightieth exhibition in November 1932. However, less emphasis was now placed on the exhibition and members were more involved in other activities. The

Sketch Club, which was organised by Ernest A. Curl and later by James Starling, was particularly successful. By 1934 there were forty-four members who attended about ten meetings a year. At the end of a meeting a subject was selected for members to paint or draw during the following month. The finished pictures were then displayed on screens at the next session when one member was called upon to criticise the work. The Club continued until 1949.

The improved standard of the exhibitions was maintained during the 1930s. Artists of the calibre of Munnings, Arnesby Brown and Walter Dexter of King's Lynn were still contributing. Charles Hobbis continued to exhibit his delightful views of Norwich and his deputy at the School of Art, Horace Tuck, and other members of the teaching staff, Leslie Moore, Hubert Miller, Susan Lascelles and Elsie Cole, were also regular exhibitors.

In practical terms the Second World War had a much more profound effect on the Art Circle than the First World War. Many members served in the armed forces, there was a shortage of paper, and petrol rationing restricted members outside Norwich from attending meetings. From 1941 to 1945 no meetings of the Council were held and the business of the Art Circle was conducted through the post.

However, the annual exhibitions still took place throughout the war, although no catalogues were printed and posters advertising the exhibitions were painted by hand. But the content of the exhibitions remained little changed and the press echoed the comments made twenty-five years earlier at the time of the First World War: 'If four years of war can be said to have had any effect on the Norwich Art Circle, this is apparent only in the reduced size of the group's ninetieth annual exhibition… Watercolours of peaceful Norfolk landscape predominate, flowers, a portrait study here and there. Is it just escapism? Only in two instances has the war furnished a theme.' (EDP, 9th July 1943). This was despite the fact that some of the exhibitors were serving members of the forces.

Towards the end of the war there was some dissatisfaction among a few of the members of the Art Circle because of the lack of activity in the field of contemporary art in Norwich. They were, however, in a minority. Indeed, the Art Circle's most eminent member and former President, Alfred Munnings, was well known for his views on modern art. He had informed the members at the 1934 exhibition that great artists did not go in for 'stunts' and that Hogarth, for example, 'never went in for Cubism and all that rubbish'! (EDP, 22nd October 1934). A small group of modernists existed within the Art Circle and in 1944, at the instigation of Walter T. Watling, some of them got together and formed the Norwich

Twenty Group. Limited to twenty members, it was originally planned as a discussion group where artists could get together to debate modern art and to discuss their own work. Most of the artists, however, retained their membership of the Art Circle and continued to contribute to the exhibitions.

In October 1946 the new group decided to hold an exhibition of members' work, but before this, two Arts Council exhibitions were held at the Castle Museum that divided the artistic community. In May there was an exhibition of work by Paul Klee and in September an exhibition of modern pictures which included such artists as Matthew Smith, Victor Pasmore, Augustus John, John Tunnard and Paul Nash. After the gloom of the war years its modernism shocked many of the people of Norwich and there was an avalanche of letters to the press, many criticising but some defending.

By contrast, the Art Circle's ninety-third exhibition which followed at the end of October came as something of a relief. 'This exhibition provides unbounded pleasure with its uninhibited pictures which require no explanations or excuses. It includes no women wearing fish for a hat, and one need not strive gallantly to conjure up an admiration or awe which is not felt.' (*Eastern Evening News*, 28th October 1946). A pointed reference to the recent controversy, which rumbled on for some time afterwards.

This situation was compounded the following year, when an exchange exhibition was held between Colchester Art Society and the Art Circle, a venture which was repeated in 1948 and again in 1949. The work of the Colchester Society, under the Presidency of John Nash, was a marked contrast to that of the Art Circle: 'There are paintings in this exhibition which the Art Circle would never show... Here in Norwich we tend to prize technique at the expense of gusto... The whole exhibition is a blend of styles which are comparatively strange to the Norwich public.' (EDP, 1st November 1948).

During the late 1940s and 1950s the Art Circle was a very active and self-sufficient group. Twenty or more events took place each year: lectures, talks on such subjects as new techniques and framing, demonstrations, life classes, working evenings, sketching weekends and criticisms of members' work. Most of them were given or organised by the members themselves and many of the activities were centred around the School of Art, whose links with the Art Circle were very apparent during this period. Noel Spencer succeeded Charles Hobbis as Headmaster in 1946 and became actively involved with the Art Circle for nearly thirty years. Members of the teaching staff were also Art Circle

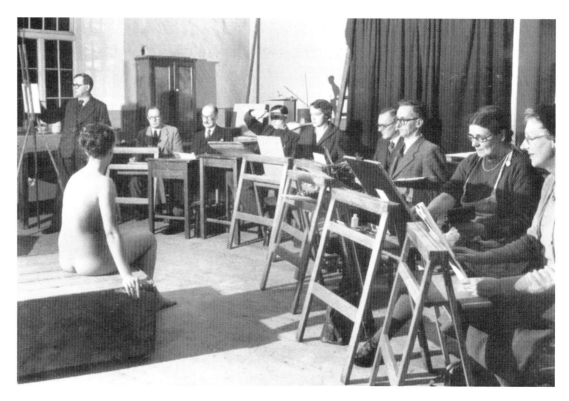

members: Tom Griffiths, Leslie Davenport and Margaret Fitzsimmons Hall. Also during this period three important contemporary artists first made their appearance in the Art Circle and all became involved in the School of Art's teaching programme. They were Jeffery Camp, Michael Andrews and the sculptor Bernard Meadows. All these visiting artists and permanent teaching staff connected with the School of Art played an integral part in the classes and demonstrations organised by the Art Circle, and members were anxious for them to give criticisms of their work so that they might benefit from their expertise. They and their predecessors at the School of Art influenced generations of students who attended their classes as full-time or part-time students, students such as Hamilton Wood, Joan Banger and Ronald Courteney.

The long association with the School of Art was only broken soon after the School received recognition to grant the Diploma of Art and Design in 1965. With the retirement of Noel Spencer in 1964 (when the Art Circle presented him with books in recognition of his long service), meetings were no longer held at the School, part-time classes ceased and the Art Circle life class moved first to Keswick Hall and later to Wensum Lodge. In recent years, however, an evening life class and a

summer school have been resumed at the School of Art which Art Circle members have been able to attend.

The year 1953 marked the Art Circle's 100th Exhibition. It was opened by Professor Anthony Blunt, Keeper of the Queen's Pictures, later exposed as one of the Cambridge spies, and included a small retrospective selection of pictures by past and present members. The catalogue contained a short history of the Art Circle and was illustrated with photographic reproductions. Photographs had been reintroduced into the catalogues in 1951, and until 1972 were donated by Jarrold & Sons.

In September 1956 the question of traditional art versus abstract art was raised again and this time was aired on local BBC radio. The discussion was chaired by Noel Spencer and two members of the Art Circle Council, Edward Hines and James Starling, defended traditional art, while a former member, David Carr, and Tom Hudson of Lowestoft School of Art, defended abstract. Each side stuck firmly to their views and no real conclusion was reached.

Towards the end of 1956 the Art Circle once again considered the idea of having its own permanent base. The society took a six months' trial tenancy of a room at the Norfolk and Norwich County Library. Meetings were held there and it was hoped that members would make full use of the room. Unfortunately they did not, and when the tenancy expired it was not renewed.

The Art Circle, however, continued over the years with a full programme of events. It joined other art societies in East Anglia in sketching weekends; it also held exhibitions at Yarmouth and King's Lynn, and the annual exhibitions at the Castle Museum continued to attract visitors. The selection process by this time was very stringent to ensure that the best possible exhibition was selected from the hundreds of pictures submitted. Members could submit two paintings each and paid a submission fee of one shilling. The pictures were assembled in an upstairs room at the shop of the framemaker George Butcher of Magdalen Street, who was the Art Circle's agent for over twenty-five years and in recognition of this he was made an Honorary Life Member in 1978. Each picture was held up for the Council to inspect and the difficult process of selecting and rejecting took a full day.

The selection process is no less stringent today. The eleven Council members inspect all the pictures submitted and those pictures receiving nine votes are immediately selected. The remainder are

inspected again and accepted on a vote of eight, then seven and so on until enough have been selected for the exhibition.

In recognition of its links with the Norwich School of Artists, the Art Circle members in 1970 subscribed towards the purchase of an oil painting by John Crome, 'New Mills: Men Wading', for the collection at the Castle Museum. The society has also presented two pictures by former members to the Castle Museum. When Leslie Davenport died in 1973, a fund was set up at the suggestion of the Chairman Joan Banger to buy one of his pictures for the museum. 'Dav' was one of the great characters of Norwich; he was a well-respected artist held in much affection. Appropriately, because of his gregarious nature, the picture, 'Shop and Girders – London Street', was hung in the bar of the Castle Museum. The second picture, 'Towards Stratford St Mary 1962', an oil by Edward Hines, was presented to the museum in his memory in 1980. Edward Hines, a traditional landscape painter, influenced by Campbell Mellon, was another leading member of the Art Circle and former Chairman.

Many of these long-serving members had done a great deal to help the Art Circle fulfil its original aim of promoting art in Norfolk. In recognition of this and as a way of thanking some of them, the office of President was reintroduced in 1974. Noel Spencer was the first to be elected and he was followed in 1977 by Raymond Banger, a non-exhibiting member, who for many years had been Honorary Secretary. In 1981 the old rank of Vice-President was also restored and three more former Chairmen who have given long and valuable service to the Art Circle were elected: Tom Griffiths, Henley Curl and Noel Dennes.

In 1985 the Norfolk and Norwich Art Circle was still strong and as active as ever, with a membership of 279. The exhibition to celebrate its centenary was appropriately held in a gallery at the Castle Museum dedicated to the memory of a young Art Circle member, Timothy Gurney, who was tragically killed in 1962. The exhibition covered a century of members' work and several interesting aspects and patterns emerged. The subject matter of the pictures had changed little over the century. Throughout its history members had been encouraged to record the changing face of Norwich, and, inevitably, views of Norwich and Norfolk have always predominated. Flower pictures, perhaps were not quite so numerous but still popular, while portrait and figurative works were less so. Although sculpture was not introduced into the exhibitions until much later, it had maintained a small section and much of it was figurative.

The Art Circle also has a fine tradition in the field of etching, an underrated art which the Art Circle did much to promote locally with the Black and White Exhibitions. These exhibitions revealed such talented etchers and engravers as C.J. Watson, Minna Bolingbroke and of course Miss C.M. Nichols, the first woman to be elected a Fellow of the Society of Painter-Etchers. They were succeeded by James Starling, Noel Spencer, Geoffrey Wales and also Christopher Penny, who used techniques unknown to the early etchers.

The Centenary Exhibition proved a great success, honouring the many eminent artists who had made a name for themselves in the wider art world, at the RA, RBA, RE, RI, ROI, RWS, SWA and elsewhere. The exhibition included artists who at the start of distinguished careers contributed to Art Circle exhibitions. Inevitably one thinks of Arnesby Brown, Alfred Munnings and Edward Seago, but there are also Frederic George Cotman and the contemporary artists Jeffery Camp, Michael Andrews, Mary Newcomb and Bernard Meadows.

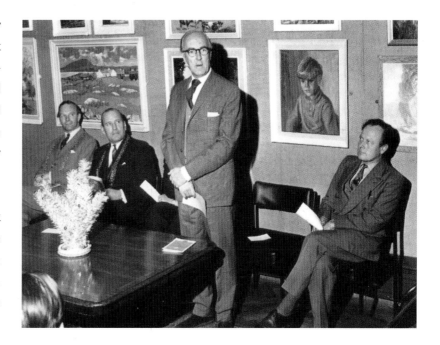

On 18th July 1985, the President Mr Tom Griffiths unveiled a plaque in Bank of England Court, off Queen Street, Norwich marking the site of the Circle's original meeting and exhibition venue. That same year, October 5th to 26th, the Circle held the 133rd Exhibition at the Crome Gallery, Elm Hill, Norwich, for members who had been deprived of their annual event in the Castle by the Centenary celebration.

Edward Seago opening the 1966 Art Circle Exhibition at Norwich Castle Museum

Eastern Daily Press photograph

In 1986, a small exhibition by the Circle Committee was held in the main hall of Barclays Bank, Bank Plain, Norwich, to publicise the Circle in an effort to attract new membership. It was a sign that all was not well and some difficult years were to follow. Incidentally, Barclays have now closed this most prestigious branch with its marble floors, columns and plaster mouldings.

The year 1992 saw a special retrospective exhibition in May held at the Assembly House in honour of eight past Chairmen, all good artists, Henley Curl, Ronald Crampton, Noel Dennes, Mildred Faulkner, Tom Griffiths, Noel Spencer and Richard Young. In the Castle a 60-year celebration of exhibitions held in the Castle Galleries took place as part of a week of events staged by the Circle. These events included clay modelling and painting demonstrations.

It was therefore a bitter blow when in the following year, the Castle informed the Circle that they could no longer mount exhibitions in the Galleries but would share the space with seven other art and craft societies. An era had ended. These new exhibitions were to last only three years. To make up for the deficiency, in June 1994 the Circle held an exhibition of fifty-five paintings and four pieces of sculpture in the Cathedral by kind permission of the Dean and Chapter. This then was to become the main exhibition venue and grew over the years since to fill the North Transept. The lighting was criticised, justifiably. In 2000, under the Chairmanship of Robert Wilson, lighting was supplied by the Circle to ensure a more reasonable standard.

On 1st of August 1994, the Norwich Central Library, including the Local Studies Library burnt down. All the Art Circle records therein were lost, including pictures donated on permanent loan. Luckily the Archivist Joan Banger had misunderstood an instruction to lodge two early minute books, 1894–1946 and 1946–1971 in the Library and had left them on permanent loan in the Castle where they remain today. The early one, handwritten, contains items by Munnings in his own hand.

In 1994 Chairman Anthony Dalton proposed that the Circle should drop out of the Castle altogether and look to having a properly funded exhibition in a commercial gallery. The Circle voted to retain the shared Castle venue, but did agree to increase membership fees which resulted in a much more healthy fiscal climate. Gradually finances built up, but in 1999 it was felt that a balance of some £4,000 was unacceptable and over the next two and a half years this balance was allowed to decrease, and in 2002/3 under Brian Watts, economies were made to bring the accounts into balance. The first act of Chairman Adrienne May in 2003 was to seek an increase from £10 to £12 p.a. to give a margin for any unexpected shortfall. This was carried by the Circle at the AGM.

In December 1994, the Circle participated in the 800th anniversary of Norwich's City Charter with an exhibition of forty-eight pictures of Norwich, in the Assembly House.

The year 1996 saw the 900th anniversary of the Cathedral and the Circle's exhibition there contained works by many long-standing members. The Circle was also informed along with other craft and art societies, that the Castle would no longer hold a December mixed exhibition. Tony Dalton's recommendation in 1994 had proved to be right and the Castle venue was now no more. The Gallery dedicated to Timothy Gurney, for the use of local artists, was eventually removed in extensive inte-

rior renovations to the Castle Museum, but has been replaced by a new gallery bearing the same name.

However, the millennium seemed to cause a renaissance. For the Millennial Exhibition, Adrienne May produced a full-colour catalogue containing 20 reproductions of exhibition works. To celebrate the millennium the preview reception was held for all members and guests, with food and wine in the South Transept. This was so successful that it has become an annual event. Advertising and sales of the catalogue more or less balance the expenses, while picture sales allow a donation to Cathedral Funds.

Reviewers over the last century have frequently commended the Art Circle members for their technical competence and honest approach. In the early exhibitions of the nineteenth century, they were criticised for introducing experimental work, but ironically during the late-twentieth century the main criticism has been that it is too entrenched in traditional values and ought to be more adventurous. Yet the Circle's exhibitions are popular and well patronised and the membership continues to grow. Frank Gordon summed up the Art Circle very succinctly when he wrote that it '… is still firmly committed to the mainstream, but it has enough little whirls and eddies to give it some pleasant variety.' (EDP, 20th December 1980). That the Norfolk and Norwich Art Circle has survived for a hundred and eighteen years and is still flourishing surely indicates that this is a successful formula.

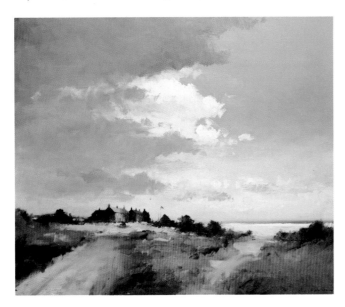

Coastal Landscape
(Ian Houston)
Oil (102 x 122) INSC: lower right Ian Houston. Kind permission of the artist

Main Reference Sources

Allthorpe-Guyton, Marjorie, with John Stevens, *A Happy Eye. A School of Art in Norwich 1845–1982*, Jarrolds, 1982.

Collins, Ian, *A Broad Canvas*.

Eastern Daily Press (EDP), specific references given in the text.

Eastern Evening News (EEN), specific references given in the text.

NORWICH ART CIRCLE

Complete set of Exhibition Catalogues from 1885 to date (Norwich Castle Museum).

Minute Books, 2 vols, 1894–1946, 1946–1975 (Norwich Castle Museum).

Norfolk and Norwich Art Circle Miscellany: Catalogues, Reports, etc. (Norwich Local Studies Library, N706).

Manuscript book of Sketch Club meetings 1936–1946 (Norfolk & Norwich Record Office, MS 21577/465x).

Exhibition Catalogues 1885–1913 interleaved with miscellaneous reports, press cuttings, etc., *ex libris* James Reeve. (George Plunkett).

Members' personal autobiographies (Joan Banger).

Waters, Grant M., Dictionary of British Artists Working, 1900–1950, Eastbourne Fine Art, 1975.

WOODPECKER ART CLUB

Incomplete set of Exhibition Catalogues 1893–96, 1898, 1901–5, 1907–8, 1910, 1912–13, 1923–24, 1926–27 (Norwich Castle Museum).

Exhibition Catalogues 1985–2003.

Catalogues and miscellaneous material relating to the Woodpecker Art Club (Norwich Local Studies Library, N706).

The Artists

Henry George Barwell 1829–1898

One of the five sons and one daughter of Norwich wine merchant John Barwell and his wife Louisa. With two of his brothers he ran his father's wine business. In 1874 he was appointed to the Committee of the Norwich School of Art and by 1884 he was Honorary Secretary, a post he held until his death. A landscape painter, he exhibited in London, including the RBA 1878–80 and the RI. He was an important founder member of the Art Circle and served as Treasurer and President. For many years he lived in Surrey Street, Norwich.

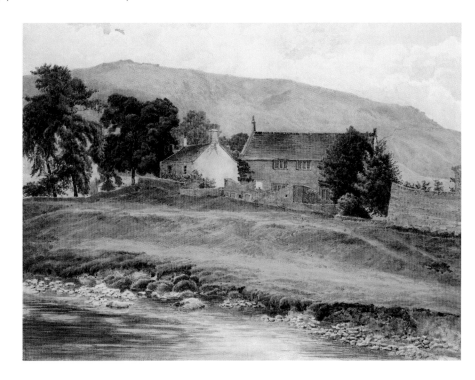

Burnsall on the Wharfe
1896 pencil and watercolour (34.5 x 44) EXH: NAC Oct. 1896 (41) Norwich Castle Museum and Art Gallery, presented by Miss Barwell 1904 (9.04)

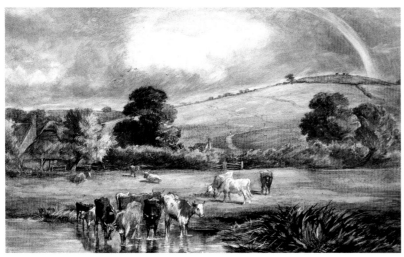

A Showery Day (Arthur James Stark)
Pencil, watercolour and bodycolour (32.5 x 50.2)
Norwich Castle Museum and Art Gallery, presented
by Harold Day 1971 (1.415.971)

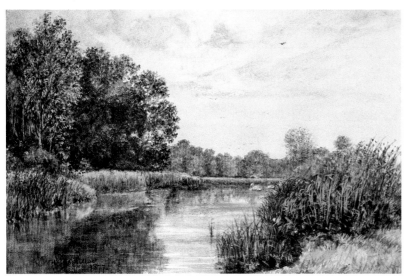

Hassingham Broad
1877 pencil and watercolour heightened with white
(25.5 x 35.8) INSC: lower left James Reeve/1877.
Norwich Castle Museum and Art Gallery, presented by
the East Anglian Art Society 1894 (55.75.94)

Arthur James Stark 1831–1902

Born in Chelsea, the son of Norwich School artist James Stark. Studied under his father and Edmund Bristow of Windsor, and in 1849 entered the Royal Academy Schools. Later in 1874 he also studied with the German animal painter Friedrich Wilhelm Keyl. From 1859 he worked as a drawing master in Windsor and London, and in 1886 he retired to South Nutfield, where he remained for the rest of his life. Exhibited at the RA 1848–83, BI 1848–67 and the RBA 1848–85, as well as Dublin, Manchester and Norwich. His landscapes in oil and watercolour prominently feature animals, and studies for many of his pictures were made at Sonning in the Thames Valley, which he visited annually for many years.

James Reeve 1833–1920

Born in Norwich. Studied at Norwich School of Art 1848–57 as a part-time student. Appointed Curator's Assistant at the Norfolk and Norwich Museum in St Andrew's Street in 1847, and in 1851 became Curator at the age of eighteen. In 1894 he supervised the removal of the museum's collection to its new home in Norwich Castle and remained Curator until his retirement in 1910 and Consulting Curator until his death. Not only was it due to his insight that the Norwich School of Artists received the recognition it deserved but he was also a generous patron of living artists. The young Alfred Munnings benefited from his patronage and as early as 1872 Reeve played an important part in the formation of the East Anglian Art Society which purchased the work of living local artists. In addition to his artistic interests, Reeve was also a keen geologist and was elected an FGS in 1901. Very few of his pictures are known and he only exhibited once with the Art Circle, but nevertheless he played a major supportive role in both the Art Circle and the Woodpecker Art Club.

Sydney Felix Howitt 1845–1915

For many years a designer and artist with the Norwich printers Fletcher & Sons, where he was responsible for preparing the Art Circle catalogues. Vice-President of the Art Circle 1902–4. Attended part-time classes at Norwich School of Art at the same time as Alfred Munnings, who described him in his autobiography as 'a good artist and draughtsman, besides being a character'. A keen angler, he designed cartoons for the menu cards for the annual dinners of the Norwich Angling Club, which were widely collected. Although mainly an illustrator and lithographer, he also painted landscapes, portraits and figurative subjects, usually in watercolour. He lived in Unthank Road, Norwich.

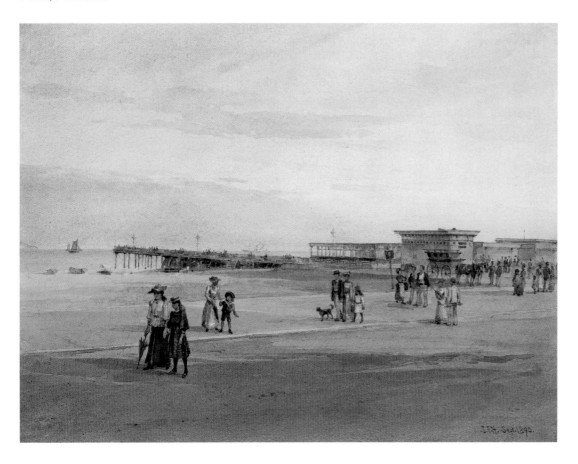

Yarmouth Jetty, Evening
1890 pencil and watercolour (20.6 x 27.4) INSC: lower right S.F.H. Sept. 1890. EXH: NAC Oct. 1891 (5) Norwich Castle Museum and Art Gallery, presented by Cyril Fry 1970 (1.48.970)

37

Charles John Watson 1846–1927

Born in Norwich, the son of a print seller and carver and gilder of All Saints Green. At the death of his father in 1865 he took over the family business, but in 1888 he left Norwich to live in London where he became a neighbour and lifelong friend of the etcher Frank Short. One of the founders of the Art Circle, he served as its first President. He made frequent visits to Holland, France and Italy which provided him with subjects for his architectural etchings and watercolours. In 1869 he began etching and was a founder member of the RE. His wife, the artist Minna Bolingbroke, whom he married in 1894, published a catalogue of his etched and engraved work in 1931. He exhibited in Europe, America and throughout Britain, including the RBA, RE, RI and RA 1872–1925. He died at his home in Girdlers Road, London.

Right: **Venice**
1891 pencil and watercolour (26.1 x 19.1) INSC: lower right Venezia 1891. /Charles J. Watson. Norwich Castle Museum and Art Gallery, R.J. Colman Bequest 1946 (1380 235.951)

Far right: **Portrait of Minna Bolingbroke**
Oil on canvas board (33 x 20.3) INSC: upper left Charles J. Watson. Norwich Castle Museum and Art Gallery, presented by the nieces and nephews of Miss Margaret Bolingbroke 1972 (2.387.972)

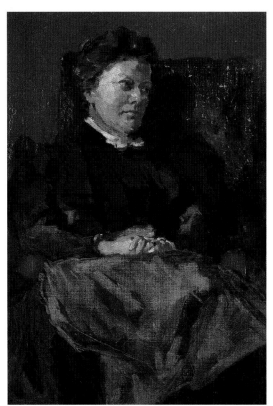

Catherine Maude Nichols 1847–1923

Born in Norwich. A self-taught artist, the only formal training she received was when she attended Norwich School of Art for two terms only in 1874. She played a leading role in the artistic life of Norwich and was President of the Woodpecker Art Club for many years. She exhibited widely in London at the RA 1877–91, RBA 1879–90, RE, the Society of Lady Artists and the Society of Miniaturists, as well as in the provinces. In addition she exhibited her work abroad, including America and Australia, and considered that she received greater recognition abroad than in her native city. She also published poems, newspaper articles and wrote and illustrated with her own etchings booklets on Norwich and Norfolk. A devoutly religious woman, she also wrote various theological publications. She worked in all mediums and painted the Norfolk landscape and the buildings of Norwich as well as subjects resulting from sketching tours made in Britain and France. She briefly visited Germany and Switzerland as well. It is, however, for her drypoint etchings that she is probably best known, and in 1889 she was elected the first (and for ten years the only) woman Fellow of the newly-formed Society of Painter-Etchers. She produced over two hundred etchings.

Old Inn, Lakenham (The Cock)
Etching (plate 17.5 x 37.8) INSC: lower right margin C M Nichols. R.E. EXH: NAC May 1904 (21) Norwich Castle Museum and Art Gallery, presented by the Executors of Miss A. Oxley 1940 (21.75.940)

Lime Pit Cottages, Ipswich Road, Norwich
Oil on canvas (43 x 79.8) INSC: lower right C M Nichols. Norwich Castle Museum and Art Gallery, presented by Dr H. Cooper Pattin 1917 (1.17)

Stephen John Batchelder 1849–1932

Born in Bolton, Lancashire, the son of a travelling showman from Norwich. The family eventually returned to Norfolk and Batchelder worked for a Norwich photographer. By 1872 he is recorded as a photographer in Great Yarmouth, where he also studied at the College of Art. In 1882 he gave up photography to pursue a career in art and soon established a reputation as a Broadland artist, working in watercolour. His great friend was Charles Harmony Harrison, and together they are now recognised as the finest watercolourists of their day. He purchased a small boat, *Smudge*, and used it to explore and paint Norfolk's waterways. He exhibited at various exhibitions in Norwich as well as the IFAC from 1883–1900. He died at his home in Garrison Road, Great Yarmouth.

Salhouse Broad, Norfolk
Pencil and watercolour (35.8 x 54) INSC: lower left S.J. Batchelder. Norwich Castle Museum and Art Gallery, presented by the artist 1928 (188.928)

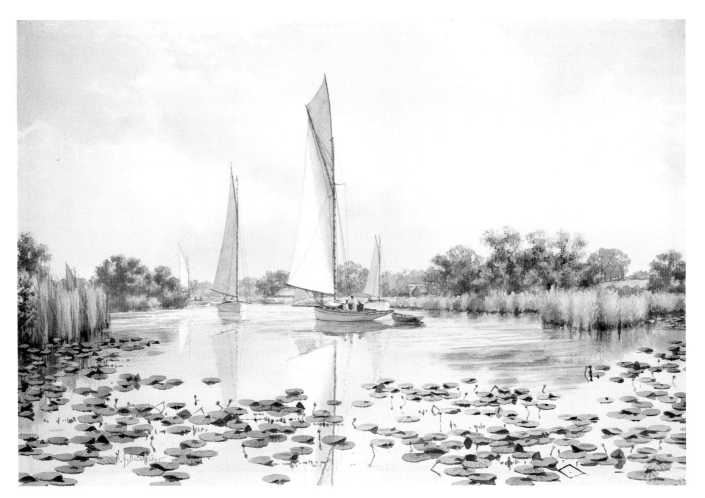

Robert Bagge Scott 1849–1925

Born in Norwich. Educated mainly in France, Scott later qualified as an officer in the Merchant Navy and travelled the world. He decided instead to pursue a career in art and was admitted as a student at the Royal Academy of Antwerp under Albert de Keyser and also had lessons from the landscape painter Jozef van Luppen. He travelled extensively in France and Holland, which provided him with subjects for pictures for the rest of his life. He married a Dutch woman and returned to Norwich where he became actively involved in the artistic life of the city. He taught art at various Norwich schools. Vice-President and later President of the Norfolk and Norwich Art Circle from 1899 until his death. He is well known for his Dutch landscape pictures and marine subjects and exhibited at the RA 1886–96. Munnings held him in high regard, calling him the 'best Norfolk painter since John Sell Cotman'. He died at his home on Bank Plain, Norwich.

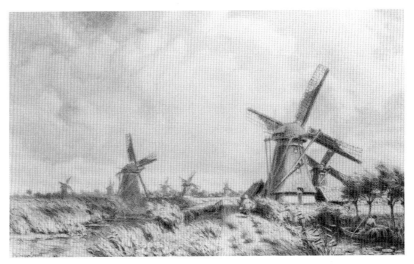

Drainage Mills on the Kinderdyke, South Holland
1919 black chalk and crayon (36.2 x 59) INSC: lower left R. Bagge Scott/Kinderdyke EXH: NAC 1919 (148) Norwich Castle Museum and Art Gallery, presented by Mrs and Miss Bagge Scott 1944 (1.11.944)

The Wind in the Willows
(Robert Bagge Scott)
Oil on canvas (25.4 x 35.6)

Portrait of Miss Catherine Maude Nichols

Oil on canvas (91.9 x 71.5) INSC: lower left Edward Elliot 19?? (illegible) EXH: WAC 1923 (to mark the death of Miss Nichols) Norwich Castle Museum and Art Gallery, presented by the members of the Woodpecker Art Club 1923 (75.23)

Edward Elliot 1850–1916

Born at Ranworth, Norfolk. Elliot was taught drawing by the Norwich School artist John Berney Ladbrooke and later studied at the Royal Academy Schools. Frederic George Cotman was also a student and the two artists became friends and together went on painting tours in Norfolk and Suffolk. Following the death of his father, Elliot took over the running of the family farm at Hethersett. Exhibited at various exhibitions in Norwich, the IFAC 1897–1901, RA 1880–1905 and from 1879–89 the RBA, of which he was elected a member in 1884. A painter of landscapes and portraits in oil, he frequently worked on large canvases. He died at Acle.

Frederic George Cotman 1850–1920

Born in Ipswich, son of the youngest brother of the Norwich School artist John Sell Cotman. Studied as a private pupil of W. Thompson Griffiths, Headmaster of Ipswich School of Art, and from 1868 at the Royal Academy Schools. He embraced the current vogue for realism and while at the Schools won four silver and one gold medal. He became a popular and fashionable portrait painter and exhibited frequently in London, including the RBA 1870–85 and the RA 1871–1904. He commanded a high price for a full-length likeness, as much as 300 guineas. He also exhibited with the RI and ROI and was elected a member of both in 1882 and 1883 respectively. In 1899 he was elected President of the IFAC where he exhibited from 1875–1916. He lived in London for several years but moved to Lowestoft in 1897 and later to Felixstowe where he died. Equally proficient in oil and watercolour, in addition to portraits he also painted historical, genre and narrative pictures, and atmospheric landscapes of the East Anglian countryside.

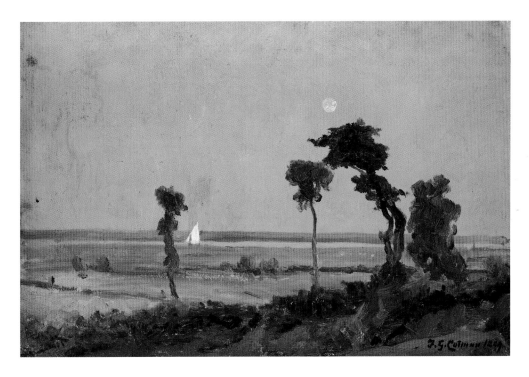

Moonlight River Scene

1899 oil on card (21.6 x 32.1) INSC: lower right F.G. Cotman 1899 Norwich Castle Museum and Art Gallery, presented by Duncan Cotman 1974 (44.474.975)

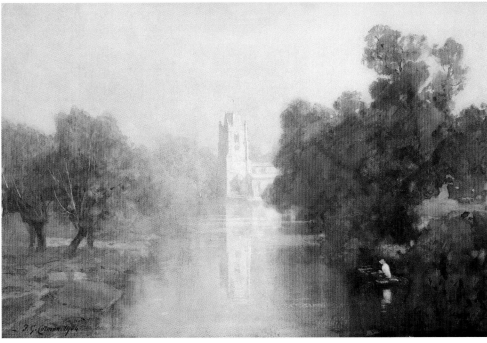

Morning Mist, Hemingford Grey

1904 pencil and watercolour (29.4 x 45.4) INSC: lower left F.G. Cotman 1904 Norwich Castle Museum and Art Gallery, R.J. Colman Bequest 1946 (35 235.951)

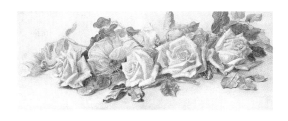

Above: **Yellow Roses**
(Fanny Jane Bayfield)
1895 pencil and watercolour (21 x 56.2) INSC: signed upper left with monogram and dated 1895 Norwich Castle Museum and Art Gallery, presented by the Executors of Mrs Marjory Lees 1978 (2.621.978)

Right: **Basket of Flowers**
(Fanny Jane Bayfield)
1880 pencil and watercolour (25.4 x 35.5) INSC: signed lower right with monogram and dated 1880 Norwich Castle Museum and Art Gallery, presented by the East Anglian Art Society 1894 (65.75.94)

Fanny Jane Bayfield 1850/1–1928

Little is known about this artist. She exhibited regularly with the Art Circle for over forty years and served as Vice-President 1926–7. A flower painter in watercolour, she exhibited in various other exhibitions in Norwich as well as in London at the RBA 1872–3 and the RA 1887–97. She lived at Bracondale, Norwich.

Miller Smith 1854–1937

Studied at the Heatherley School of Art, London, and later in Antwerp and Paris. In 1881 he settled in Norwich, where he remained until 1911. He retired to the Westcountry. The founder of the Woodpecker Art Club, he served as Vice-President and continued to contribute to its exhibitions after he had left Norwich. Exhibited at the RA 1885–1903, and the Paris Salon, and in 1899 was

elected a member of the Société des Beaux Arts. In addition he exhibited with the IFAC and various exhibitions in Norwich. A wood engraver, he also worked in oil and watercolour and painted landscapes and city views.

Above left: **St Helen's Hospital, Norwich**
Oil on canvas (35.6 x 45.4) INSC: lower right MILLER SMITH EXH: WAC Oct. 1893 (58) Norwich Castle Museum and Art Gallery, presented by the Revd G.O. Morgan Smith 1956 (2.164.956)

Above: **A Norfolk Marl Pit**
1904 pencil, watercolour and bodycolour (35.6 x 53.1) INSC: lower left MILLER SMITH. 1904. Norwich Castle Museum and Art Gallery, presented by F.G. Shields 1933 (164.933)

Frederic George Kitton 1856–1904

Born in Norwich, the son of Frederic Kitton, a scientist who wrote many papers on microscopic investigation. Trained as a draughtsman and wood engraver, and until 1882 worked for the *London Graphic* newspaper. He left to devote himself to art and to the study of Charles Dickens and his work, and wrote and illustrated several books on Dickens. He lived in London, but by the late 1880s he appears to have moved to St Albans. In addition to wood engraving he worked in watercolour and pencil, and between 1871–89 exhibited views of Norwich and London in various exhibitions in Norwich as well as at the RBA in 1880. He died in London.

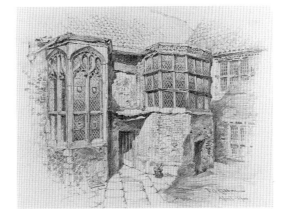

View of the outside of the windows at Strangers' Hall, Norwich
1900 pencil (25.1 x 35.8) INSC: lower right F.G. Kitton/April 1900. Norwich Castle Museum and Art Gallery, Bolingbroke Collection 1922 (2.135.22)

Top: **The Rabbit Hutch**
1905 etching (plate 14 x 20) INSC: in plate lower left MB/1905; lower left in pencil Minna Bolingbroke and lower right The rabbit hutch

Above: **Ducks at the Waterside**
1916 etching (plate 15.2 x 20.3) INSC: in plate lower right MB 1916; lower left in pencil Minna Bolingbroke. Norwich Castle Museum and Art Gallery, presented by the Executors of the artist 1939 (139.939)

Above right: **St Marks, Venice**
1900 pencil and watercolour (23.2 x 33.4) INSC: lower left MB. 1900. Venezia. Norwich Castle Museum and Art Gallery, Miss M.B. Bolingbroke Bequest 1972 (388.972)

Minna Bolingbroke 1857–1939

Born in Norwich, granddaughter of the Norwich School artist James Stark and cousin of Leonard G. Bolingbroke, first Secretary of the Art Circle. Pupil of the artist Charles John Watson, whom she married in 1894. Moved to Girdlers Road, London, where she remained for the rest of her life. An etcher and landscape painter in watercolour, she exhibited her work in various exhibitions in Norwich before her marriage, and later in London at the RBA 1888, RE and RA 1891–1904. Elected an RE 1899.

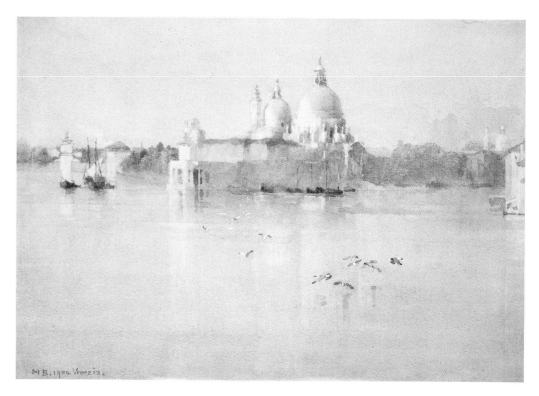

Sir John Alfred Arnesby Brown RA 1866–1955

Born in Nottingham. Studied at Nottingham School of Art and from 1889–92 under Hubert von Herkomer at his school at Bushey. He was a member of the Nottingham Society of Artists and its President from 1912–20. Arnesby Brown was in the grand tradition of English landscape painters,

following in the footsteps of Constable, Turner, Gainsborough, Cotman and Crome, but his eye was also on the Continent. He admired the boldness of the Impressionists, in particular Corot and Millet, and emulated the bravery and looseness of their brush strokes. He lived in Chelsea, but for many years divided his time between Norfolk and St Ives, Cornwall. Campbell Mellon was a devotee, Munnings a fellow traveller, who followed him as President of the NNAC. Following the death in 1931 of his wife, the artist Mia Edwards, he moved permanently to Haddiscoe, Norfolk, having purchased the White House, where he died. He became President of the Norfolk and Norwich Art Circle 1928–31 and 1935–37, and President of the Great Yarmouth and District Society of Artists 1935. He exhibited at the RBA 1893 and the RA 1890–1942 and was elected a member in 1915. He received a knighthood in 1938. A painter of the English landscape, his work frequently features cattle and the broad Norfolk skies which originally attracted him to the county.

Above: **Cattle on the Marshes**
Oil on panel (15.9 x 23.5) INSC: lower left monogram AB Norwich Castle Museum and Art Gallery, purchased out of the Doyle Bequest Fund 1948 (99.948)

Left: **The Marshes from Burgh Castle**
(Sir John Alfred Arnesby Brown RA)
Oil on canvas (65.4 x 85.4) Norwich Castle Museum and Art Gallery

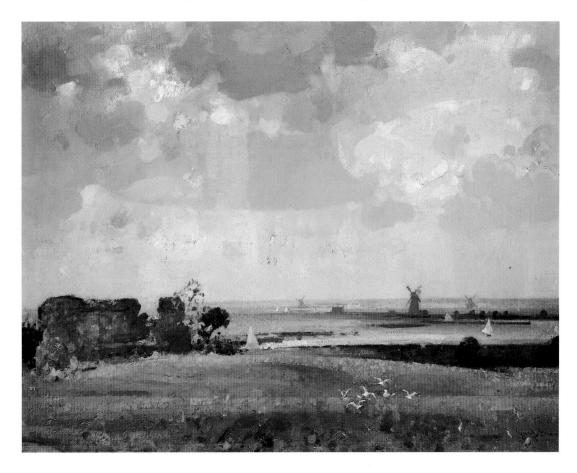

Gertrude Elizabeth Offord 1861–1903

Born in Norwich, in St Giles Street, where she lived throughout her life. Studied at Norwich School of Art under Woodhouse Stubbs, and as a student won many of the major prizes. In 1889 she was appointed as Assistant Pupil Teacher at the School, and eventually she joined the staff to teach painting and design. She was much admired by Alfred Munnings when he was a student there in the 1890s. She also taught private pupils. In 1892 she exhibited at the Women's Exhibition in Paris, in 1893 at the World Fair at Chicago and from 1894–1903 at the RA. Following her death, a memorial selection of her work was included in the Art Circle's 1904 exhibition, and a fund was set up for an annual prize to be awarded in her memory to the best still life study by a student at Norwich School of Art. She was mainly a still life and flower painter in watercolour, although some landscape subjects are recorded. Her work is sometimes confused with that of her sister, Georgina E.W. Offord (d. 1932), who was also a watercolour artist.

Still Life

1886 pencil, watercolour and bodycolour (40.2 x 55.4) INSC: lower right Gertrude E. Offord. Norwich Castle Museum and Art Gallery, presented by Miss Georgina Offord 1924 (133.24)

Interior of the old School of Art
*1897 pencil and watercolour (73.8 x 52.7) INSC:
lower right Gertrude E. Offord. 197. Norwich Castle
Museum and Art Gallery, presented by Mrs
J.E. Burton 1934*

Margaret Holmes 1868–1961

A member of the Holmes family who originally lived at Tivetshall Hall, Norfolk. From about 1884 studied at Norwich School of Art, where she became one of the most successful pupils passing all stages of the South Kensington Course, finally obtaining an Art Mistress' Certificate, Group 1. In 1892 exhibited at the Women's Exhibition in Paris. Joined the staff of the Norwich School of Art and also taught private pupils and art classes. A painter of landscapes, flower subjects and interiors in oil and watercolour. She lived in Queens Road, Norwich.

Norwich Cathedral Cloisters

1891 pencil and watercolour (53.8 x 73.5) INSC: lower left Margt. Holmes. Norwich Castle Museum and Art Gallery, bequeathed by the artist 1961 (257.961)

Geoffrey Birkbeck 1875–1954

Born at Stoke Holy Cross, Norfolk. Studied painting under Onorato Carlandi. In 1908 wrote and illustrated *Old Norfolk Houses* which contained thirty-six reproductions of his watercolours, published by Jarrold & Sons. Travelled extensively in Italy particularly Rome and Venice, France and Spain. Served as Secretary and Treasurer of the Art Circle and President 1925–31 and 1938. In 1931 he moved to London where he gave lessons in watercolour painting, but later returned to Norfolk. A landscape painter in watercolour, noted for his Norfolk landscapes and Venetian views, he also painted still lifes and portraits as well as a series of murals of Italian views at Bracondale Woods, Norwich. Exhibited at the NEAC 1909, the RBA and various one-man shows in London, Paris and Norwich. Died at Poringland.

Beeston Church, Norfolk
1939 pencil and watercolour (36.8 x 53.4) INSC: lower left G Birkbeck 39. Norwich Castle Museum and Art Gallery, presented by the artist 1940 (123.940)

Norwich Market Place
1939 pencil and watercolour (48.5 x 64) INSC: lower right G Birkbeck 1939. Norwich Castle Museum and Art Gallery, presented by the artist 1940 (121.940)

Campbell Archibald Mellon 1876–1955

Born in Sandhurst, Berkshire. In 1903 settled in Nottingham where he was a member of the Society of Artists. Arnesby Brown was President of the Nottingham Society of Artists from 1912–1930. Almost certainly Mellon was influenced by the great man's style. He received no formal training in art, although he studied under Carl Brenner in Nottingham and from 1918–21 under Arnesby Brown in Norfolk. In 1918 he gave up his work as a traveller in wholesale groceries and moved to Gorleston to paint professionally. It was then that his previously muddy style came to life as he delighted in the crowded beach scenes he now beheld. He remained there for the rest of his life except for during the Second World War when he lived in Ross-on-Wye. The first of 50 of his paintings to go on show at the RA, entitled 'August Bank Holiday, Gorleston on Sea' was exhibited in 1924. He exhibited at the ROI and RBA and was elected a member of both in 1938 and 1939 respectively. He exhibited at the RA 1924–55 and the Royal West of England Academy and was a founder member and Chairman of the Yarmouth and Gorleston Art Society from 1927 until his death. A painter in oil, he is noted for his Gorleston beach scenes full of tiny figures, although he also painted the quays and coastline of Suffolk and Norfolk as well as scenes in Kent and the Wye Valley. His paintings were purchased for a song by visiting thespians, Beryl Reid paying £5 while playing in Great Yarmouth. Actor John Mills, a local boy, enjoyed Mellon and added him to his collection.

August Bank Holiday, Gorleston
Oil on canvas (50.8 x 60.8) INSC: lower right C A. Mellon. Photograph by kind permission Keys Fine Art Auctioneers, Aylsham

Walter Dexter 1876–1958

Born in Wellingborough, but grew up in King's Lynn where he received some instruction in art from Henry Baines. Later studied at Birmingham School of Art. For several years he travelled in Europe studying the art and architecture of the old masters and wrote articles about his travels for the British press. From 1916–20 art master at Bolton Grammar School and later at King Edward VII School, King's Lynn. Exhibited in London at the RA 1923–47 and the RBA, of which he was elected a member in 1904. Founder President of the King's Lynn Art Club. In his early years he was influenced by the Pre-Raphaelites, but in the early 1900s he concentrated more on landscapes of local scenes, in oil and watercolour. Also an etcher and illustrator. Many of his watercolours were used to illustrate various books published by Methuen and he also designed posters and other types of commercial material.

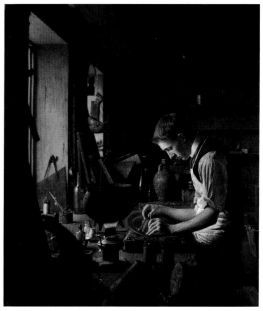

Above: **A Workshop**
Oil on canvas (68.1 x 60.2) INSC: lower left in monogram W.D EXH: WAC Nov. 1901 (15) Norwich Castle Museum and Art Gallery, purchased 1901 (56.01)

Left: **Slaughden Quay, Aldeburgh**
Pencil and watercolour (23.3 x 31.4) INSC: lower right Walter Dexter. R.B.A. Illustrated in W.A. Dutt, Some Literary Associations of East Anglia, Methuen, 1907, frontispiece. Norwich Castle Museum and Art Gallery, presented by Dr H.C. Pattin 1917 (19.17)

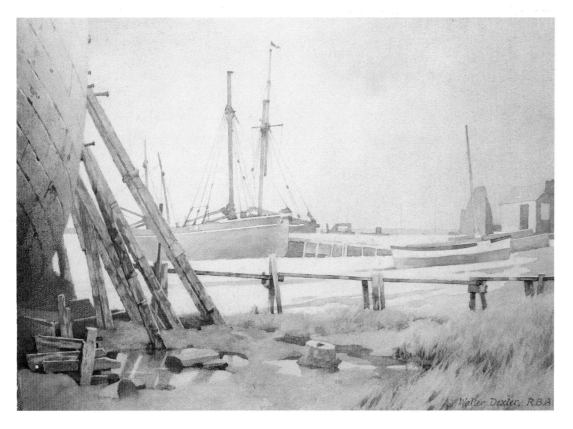

J. Miller Marshall active 1878–1925

Son of Edinburgh-born Peter Paul Marshall, who came to Norwich in about 1875 to take up the post of City Engineer. He was also an artist and sometimes worked under the name of 'Peter Paul'. J. Miller Marshall was an active member of the Art Circle, organising the life classes in the 1880s and serving as Vice-President 1888–93. In 1892–3 he visited Australia, and his work is represented in collections there. On his return he and his father held a joint exhibition in the Art Circle's rooms in December 1893, prior to their move to Teignmouth, Devon. P.P. Marshall died there in 1900 and in 1902 his son moved to Clifton, Bristol, and by the 1920s is recorded as living at Minehead, Somerset. A painter of landscapes and townscapes in oil and watercolour, he exhibited at the RA 1886–97, RBA 1890–1 and RI, as well as various exhibitions in Norwich and the provinces.

Beccles from the Railway Bridge
1885 pencil and watercolour (30.6 x 60.6) INSC: lower right J Miller Marshall/1885 EXH: NAC Sept. 1885 (37) Norwich Castle Museum and Art Gallery, purchased 1983 (1.133.983)

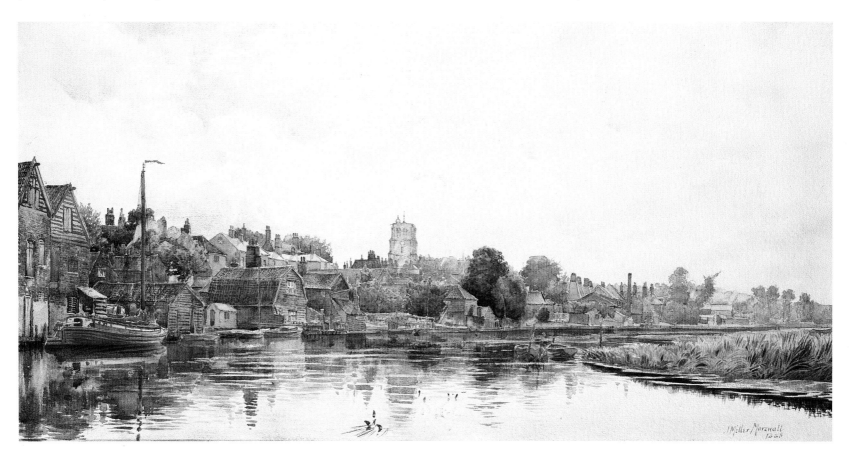

Sir Alfred James Munnings RA 1878–1959

Born at Mendham on the Suffolk/Norfolk border, Munnings like Constable was the son of a miller. As a child he would have had plenty of opportunity to observe and paint horses. He was also living in the same countryside that Constable had adored and portrayed. He was apprenticed at the age of fourteen to Page Bros. Ltd, a firm of Norwich lithographers, for six years as a poster designer. During this time he attended evening classes at Norwich School of Art, studying under the floral water-colourist, Gertrude Offord, an NNAC member. He began exhibiting with the Circle and, in 1898, the first of nearly 300 of his paintings was hung at the RA. At the end of his apprenticeship he returned to Mendham and later moved to Swainsthorpe near Norwich. In 1899, as a result of an accident, he was blinded in his right eye. He studied at Frank Calderon's school for animal and landscape painting at Finchingfield. He studied for a short time in 1902 at Julian's Atelier in Paris and between 1908–16 frequently visited Newlyn in Cornwall where he became acquainted with a group of eminent artists established there. During the First World War he was an official War Artist attached to the Canadian Cavalry Brigade in France, and by 1920 he had settled in Dedham, Essex, where he was to remain for the rest of his life, although he also had a studio in London. President of the Art

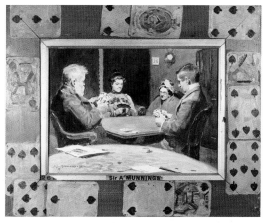

The Card Party
Pencil and grey wash in painted frame (22 x 31.1) INSC: lower left A.J. Munnings .98. EXH: NAC May 1898 (18) as 'Whist, one more round'. Norwich Castle Museum and Art Gallery presented by W.G. Munnings 1961. Permission acknowledged to the Sir Alfred Munnings Art Museum, Dedham, Essex, England

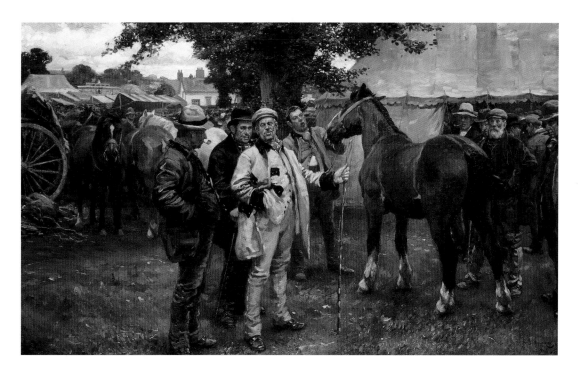

The Horse Fair
1904 oil on canvas (76.8 x 128) Norwich Castle Museum and Art Gallery. Permission acknowledged to the Sir Alfred Munnings Art Museum, Dedham, Essex, England

The Gravel Pit in Suffolk
Oil on canvas (125.7 x 183) Norwich Castle Museum and Art Gallery. Permission acknowledged to the Sir Alfred Munnings Art Museum, Dedham, Essex, England

Circle 1932–4. Exhibited widely in East Anglia, including with the IFAC. Exhibited with the RA 1899–1959, elected a member in 1925 and served as President 1944–9. Knighted 1944, and in 1947 received the KCVO. Also elected RWS in 1929. Autobiography published in three volumes 1950–2. He was an extremely successful painter in oil and watercolour, noted for his pictures of horses and race meetings, and the commissions for these horse portraits paid for his lifestyle. He found them irksome, wanting to paint landscapes and figurative subjects. He wrote to his wife, 'When you want peace, paint willows and lily-leaves'. As Jeffery Camp RA found, Munnings had no love for modernists and agreed with Churchill that he would like to kick Picasso's bottom. In 1928 a retrospective of his work in Norwich Castle Museum attracted 86,000 visitors. It was a time of change and changing tastes. In 1986 a major loan exhibition mounted in Manchester, failed to find exhibition space in London. Castle House, Dedham, is now a Munnings Museum and a place of sheer delight.

St Stephen's Street, Norwich
1938 pencil and watercolour (24.6 x 34.8) INSC: lower left St Stephen's Street/Norwich./C.W.H. July 1938. EXH: NAC 1946. Norwich Castle Museum and Art Gallery, presented by the artist 1976 (1.43.976)

Charles Wilfred Hobbis 1880–1977

Born in Sheffield. From 1893–1902 studied at Sheffield School of Art, where he won numerous prizes culminating with a Royal Exhibition to study design at the Royal College of Art for five years. During this time he began to study silversmithing, metalwork and sculpture. Obtained ARCA in design in 1907 and joined the staff of Norwich School of Art where he taught modelling, design, metalwork and jewellery. Appointed Headmaster in 1919, a post he retained until 1946. Exhibited at the RA 1918. Vice-President of the Art Circle 1920–7, and in 1928 published a series of lessons in the development of pattern design. He designed and made in silver or other metals such objects as commemorative plaques, frames, church silver, coffee pots, jewellery, etc. His drawings and watercolours of the streets and lanes of Norwich and surrounding countryside were very much a summer holiday occupation. They were usually drawn and painted on the spot and are a valuable record of the changing face of Norwich. In 1976 he presented a collection of these drawings to the City of Norwich. He died at Sheringham.

Popes Head Yard, Norwich

1935 pencil and watercolour (35.4 x 28) INSC: lower left Popes Head Yard./CW.H. July 1935. Norwich Castle Museum and Art Gallery, presented by the artist 1976 (6.43.976)

Thorpe Hall
*1896 watercolour (54.5 x 37.3) INSC: lower right
K. Sturgeon EXH: NAC Oct.1896 (90). Private
Collection*

Kate Sturgeon active 1881–1915

Little is known about this artist. From 1881–95 she lived at Doddington Grove, London, and from 1896 her address is given as Oak Cottage, Thorpe. Exhibited at the RBA 1881–91, RA 1890–5 and RI. She was a genre, landscape and portrait painter in oil and watercolour.

Elsie Vera Cole 1885–1967

Born at Braintree. Studied at Norwich and Chelmsford Schools of Art and in 1919 joined the staff of Norwich School of Art where she taught etching until 1941. In 1919 a collection of her drawings of the buildings of Norwich appeared in a publication, *Norwich, A sketchbook*, published by A. & C. Black. Although probably best known for her etchings of Norwich, she also worked in oil and pastel and exhibited several landscapes resulting from visits to the Continent. Exhibited in London, including the RI, and for many years until her death, lived in Claremont Road, Norwich.

Britons Arms, Elm Hill, Norwich
*Etching (plate 20.8 x 14.1) INSC: not autograph,
lower left margin Briton's Arms. Elm Hill/Norwich;
lower right Elsie V. Cole. Private Collection*

Rowland Fisher 1885–1969

Born in Gorleston, where he lived throughout his life. The son of a master mariner, originally he too wanted to go to sea but instead worked at Jewson & Sons timber yard, Great Yarmouth, for fifty years. Nevertheless he had a lifelong love of ships and the sea and became an expert ship modeller. It is for his marine subjects in oil and watercolour that he is best known although he also painted landscapes of Norfolk and rural scenes resulting from visits to France, Italy and Holland. He helped found the Great Yarmouth and District Society of Artists. From his house in Upper Cliff Road, shared with his sister, he could see the ships and sat there sketching and painting. He loved the movement of the waves, ships, skies and gulls. In 1938 he was elected a member of the Royal Society of Marine Artists.

He won the Watts Prize in 1949 for the best picture portraying men working at sea. Some years later he was made a member of the ROI. In addition he exhibited at the RA 1949, the RBA, RI, RWS, as well as in Europe and East Anglia. He was a member of the St Ives Society of Artists and often painted in Cornwall. President of the Yarmouth District Society of Artists, he influenced many of the East Anglian Broadland and landscape artists.

Fishing off Gorleston
Oil on canvas (77.0 x 102). INSC: lower right, Rowland Fisher. Private collection, Judy Hines Art Gallery, Fish Hill, Holt

Alice Bolingbroke Woodward active 1886–1917

Lived in London. Exhibited at the RBA 1886–90, RA 1890–1900 and RWS. She was an illustrator, graphic designer and watercolour artist of narrative subjects and designed cards, posters and book covers. She also illustrated books and magazines, including the *Illustrated London News*, *Pall Mall Magazine* and *Woman*.

Prehistoric Hunting Scene
1910 (illustration for the Illustrated London News, *5th November 1910) pencil (36.8 x 27.5) INSC: lower left ALICE B WOODWARD. Norwich Castle Museum and Art Gallery, presented by Miss Woodward 1951 (218.951)*

Ethel Buckingham d.o.b. unknown, active from 1887; d.1918

Born in Norwich. Studied under Joseph Woodhouse Stubbs at Norwich School of Art where she won several annual Art and Science Department prizes. She later became an assistant teacher there, but by 1890 left to continue her studies at Hubert von Herkomer's school at Bushey, where she also had a studio. Exhibited at the Woman's Exhibition in Paris in 1892 and from 1893–1901 at the RA. She married Charles Havers of Norwich c.1897–8, and after her marriage painted mainly as a hobby, although she received some commissions for portraits. A painter of portraits and miniatures of children, she also painted flower subjects and landscapes in oil and watercolour.

Still life of Pots with kettle and beads
1887 pencil and watercolour with some gum arabic (41.4 x 60) INSC: lower right Ethel Buckingham Norwich Castle Museum and Art Gallery, presented by Miss Kathleen Havers 1978 (3.88.978)

Sir Cedric Morris 1889–1982
The son of a wealthy iron founder born in Sketty near Swansea. After Charterhouse School, he attended the Royal School of Music then worked for a time on a farm in Canada. 1914 found him studying art in Paris when he was called for military service. Unfit for active service he was discharged but volunteered to train army horses at Lord Rosslyn's stables near Reading where he met Alfred Munnings. He began painting in watercolour while at Zennor. 1918 found him back in London, mixing with painters, dancers and actors. He met Arthur Lett-Haines and a deep friendship ensued only broken by death. In 1919 they went to Newlyn where Morris learned oil painting. After further time in Paris and London, they moved to Suffolk in 1936 establishing the East Anglian School of Painting. The first house was burnt down. A student, David Carr, and Lucien Freud had worked long into the evening and had probably left a discarded cigarette. The next day the students painted the smouldering ruins. Munnings, who had been a friend and had inspired Morris, was horrified by his move to post-impressionism. Munnings hated modernism and as the fire raged he was driven up and down the street in Mendham shouting 'Hurrah, hurrah'. They moved to Benton End. Morris gradually tamed an unkempt garden and Haines cooked sumptuous meals from Morris's produce. It was a relaxed and free atmosphere, lively and uninhibited. Many eminent painters attended the school. NNAC member Henley Curl was a student and Slade-trained Iris Francis, NNAC President 2002–4, met Henley there during the war. Cedric inherited his father's baronetcy in 1947. In 1984 the Tate mounted a posthumous exhibition of his work as did Norwich Castle in 2002.

Opposite: **Solva**
(Cedric Morris)
1934 oil on canvas (60.4 x 73.4) Norwich Castle Museum and Art Gallery

Rounding the Buoy, Wroxham

Oil on canvas (41 x 61.5) INSC: lower right C M. Wigg. Private Collection

Charles Mayes Wigg 1889–1969

Born in Nottingham. From 1911 studied at Norwich School of Art and later with John Spenlove at the Yellow Door Studio, Beckenham. Served in the First World War, but was seriously wounded at Gaza in about 1916 and invalided out of the army. He had a studio at Brundall, Norfolk, and later at Barton Turf, and often worked from a boat on the Broads. Exhibited at the RA 1915, the British Watercolour Society and various exhibitions in Norwich and Yorkshire, where he sometimes worked with Joseph West. A Broadland and landscape artist, wherries feature prominently in his pictures which he painted mainly in watercolour, although he also worked in oil and produced some etchings. His life ended tragically. He married his mother's nurse and she prevented him from painting, breaking his brushes and together they burned his paintings. Later he tried to take it up again but failed to achieve what he wanted. He died at Eastbourne.

Above: **Monty**
(Nell G. Dickson)
c.1911 bronzed plaster (30.5 x 37.5 x 22.5) Private Collection

Right: **Succulent Plants**
c.1957 pencil and watercolour (59.1 x 50.1) INSC: lower left N.G. DICKSON Private Collection

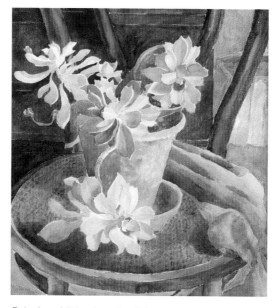

Nell G. Dickson 1891–1966

Born in Reading. Studied under William G. Collingwood 1910 and the following year at Reading University under Alan Seaby. Over the years she received instruction from various other notable artists: Herbert Maryon at the Heatherley School, London, 1911, Leonard Richmond 1935–8, Hervey Adams and David Cox 1951. Settled in Norwich after the First World War and became involved in various women's organisations, the Girl Guides and in 1955–6 was Lady Mayoress. Her original ambition was to be a sculptor and in 1911 (as Nell Price) exhibited at the RA. Later she painted in watercolour, mainly landscapes and flower subjects. Chairman of the Art Circle 1940–41 and in 1953 elected a member of the SWA. Exhibited also at the Royal Scottish Academy, the Royal Cambrian Academy and various exhibitions in the provinces.

William Large active 1892–1937

Little is known of this artist except that he was a Verger at Norwich Cathedral 1934–6. He worked in watercolour and pen and ink and exhibited mainly views of Norwich and occasionally flower subjects. In 1937 a small representative selection of his pictures was shown in the Art Circle exhibition to mark his association of almost twenty-five years with the Art Circle and the Woodpecker Art Club.

Strangers' Hall, Norwich
1904 pencil and watercolour (46.6 x 32.3) INSC: lower left Wm Large/aug/04. Norwich Castle Museum and Art Gallery, presented by Mrs Lea Rayner 1937 (1.18.937)

The Market Place, Lavenham
1956 watercolour and pencil (25.3 x 41) INSC: bottom left corner LR Squirrell 1956. Ipswich Borough Council Museum and Galleries (R1988-106.2)

The Orwell at Pin Mill, Suffolk
1956 watercolour (25 x 45.7) INSC: bottom left corner LR Squirrell 1956. Ipswich Borough Council Museum and Galleries (R1988-106.1)

Leonard Squirrell 1893–1979

Born in Ipswich. He was educated at the Ipswich School of Art where he was spotted by the Principal, George Rushton, who compared him to John Sell Cotman. Rushton was correct, Squirrell developed into one of the region's finest exponents of the watercolourists' art. He won a gold medal at the age of 18 for a view of Ipswich and the Orwell, which involved his climbing several times by ladder, to the top of the gasometer. His first picture was exhibited at the RA when he was only 17, and he repeated this for the next 47 years. He painted throughout the British Isles and on the Continent but his first love was Suffolk. He was elected member of the Royal Society of Painters in Watercolour in 1941. One wonders what took them so long, but it may have been his intense shyness due to deafness with a speech impediment, that held him back. He exhibited little with NNAC but contributed 64 consecutive years to the Ipswich Art Society. He had a retrospective in Christchurch Mansion a year before his death. His son was also talented as a painter and illustrator, becoming editor of the *East Anglian Magazine*, tragically dying at the age of 24. Leonard replaced his son as editor, finding work an antidote to his grief.

Arthur Edward Davies 1893–1988

Born in Pontrhydygroes, Ystrad Meurig, Cardiganshire. Studied at the Metropolitan School of Art, Dublin, under George Atkinson. First came to Norfolk on leave from the army in 1918 and in 1923 settled permanently in Norwich. He loved the old city and revelled in the countryside of Cotman. He painted them both over the 70 years he lived in Norfolk. Elected RBA 1939 and a member of the Royal Cambrian Academy in 1942. Also exhibited at the Royal Scottish Academy, the Royal West of England Academy and the RA 1936–67, as well as the provinces and Paris. Painted landscapes, townscapes and seascapes, mainly in watercolour, although he also worked in oil, and many of his East Anglian scenes are painted from sketches made years before. He was a companion of Campbell Mellon on many painting and sketching expeditions.

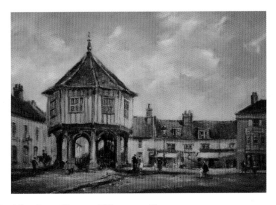

Market Cross, Wymondham
Oil on board (24.5 x 34.5) INSC: lower left Arthur Davies. Private Collection

John Cyril Harrison 1898–1985

Born at Tidworth, Wiltshire. From an early age he showed an interest in drawing animals and birds and in 1912 went with his parents to British Columbia, where he was able to study bird and animal life. They remained there for three years. He also began to collect bird skins and to study taxidermy in order to gain a knowledge of bird anatomy. After military service in the First World War he went to the Slade School of Art and soon decided to specialise in bird painting in watercolour. He settled in Hainford. Much of his work was done in Norfolk, where he made drawings from hides in the nature reserves and Broadland areas, although he also observed wildlife in Iceland, Norway, Scotland and South Africa. He wrote and illustrated *Bird Portraits*, published by Country Life, 1949, and his watercolours have been reproduced in other bird books and magazines. Exhibited in London, East Anglia and abroad and had several one-man shows at the Tryon Gallery, London.

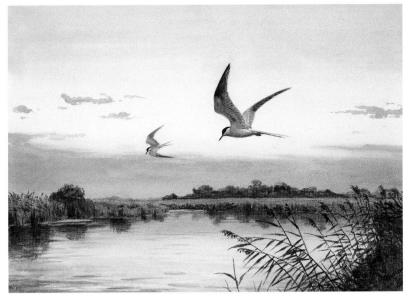

Common Terns over Heigham Sound, Hickling
1976 watercolour (39.4 x 57.5) INSC: lower right J C Harrison. Norwich Castle Museum and Art Gallery, presented to the City of Norwich by the Norfolk Naturalists' Trust on the occasion of the Trust's Golden Jubilee 1976 (173.980)

A Norwich Bedroom

1970 gouache (38.1 x 27) INSC: lower edge A NORWICH BEDROOM (Over Hovells shop, Bridewell Alley) Noel Spencer/March 1970 EXH: ANC 1971 (49). Private Collection Mr and Mrs R.H. Banger

Following the death of Mr Hovell, his bedroom was left as it was and locked for fifteen years. Noel Spencer was there to record the scene when the door was finally unlocked in 1970

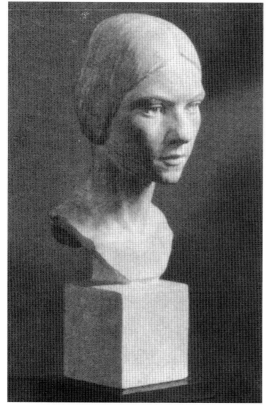

Polytechnic Model

1920 plaster (height 56) INSC: incised on back 'MAIDIE' Buckingham. Collection Mr Paul Jackson

Noel Woodward Spencer 1900–1986

Born at Nuneaton. Studied at Ashton and Manchester Schools of Art and from 1923–6 attended the Royal College of Art. Taught at Schools of Art in Birmingham, Sheffield and Huddersfield, and in 1946 was appointed Headmaster of Norwich School of Art where he remained until his retirement in 1964. A leading member of the Art Circle, he served as Chairman 1955–6 and President 1974–6 and was made an Honorary Life Member in 1975. Exhibited with the RA 1926–54, the Royal Birmingham Society of Artists, of which he was a life member, and Huddersfield Art Society. He has also published books on Huddersfield and Norwich, illustrated with his own drawings and photographs. In addition to working in oil and watercolour, he worked in pen and ink and was a skilful etcher, although he ceased etching in 1940. His subjects were historic buildings, alleyways and wharves and he had a particular interest in the churches of Norwich.

Florence Maidie Buckingham 1901–1988

Sculptor of figurative subjects and portrait plaques. Born in Norwich, daughter of Ernest H. Buckingham and niece of Ethel Buckingham, both prominent members of the Art Circle. She was a member from 1924 and to mark her long association with the Art Circle was made an Honorary Life Member in 1984. She studied at Norwich School of Art and at the London Polytechnic. Her portrait plaques are in various institutions in America, London and Norwich.

Tom Griffiths 1901–1990

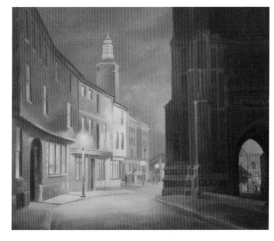

Old St Peter's Street
Egg tempera on canvas (40.5 x 51). INSC: lower right Tom Griffiths. Private collection, Judy Hines Art Gallery, Fish Hill, Holt

Studied at Norwich School of Art under Charles Hobbis and Horace Tuck, and later at the Heatherley and Grosvenor Schools, London. Worked as an illustrator in London 1930–40 and in 1940 joined the staff of Norwich School of Art and became Senior Lecturer in Graphic Design until 1950, when he left to become a freelance artist. Held various offices in the Art Circle, culminating with the Presidency in 1982, and in recognition of this was made Honorary Life Member in the same year. Exhibitied at the RA, ROI and the National Society of Painters, Sculptors and Gravers and was elected a Fellow of the Royal Society of Arts. He worked in oil and watercolour and was noted for his views of Norwich by night. He also illuminated vellum scrolls, including the Book of Remembrance in Norwich Cathedral and Honorary Freedom scrolls which have been presented by the City of Norwich to various members of the Royal Family and other eminent visitors.

Sister Benedicta 1904–2000

Sculptor of figurative subjects and portrait heads. Born in East Dereham. Entered the Community of St Peter the Apostle in 1930 and took life vows in 1934. Trained at the Community's School of Embroidery in Scotland and in 1947 became a full-time student at Norwich School of Art, where she studied general design under Margaret Fitzsimmons-Hall and Noel Spencer. During this time she first became interested in sculpture. She later became Sacristan at Dereham Church. She also exhibited in one-woman shows in Dereham and Norwich.

Girl with Kite
(Sister Benedicta)
1962 bronzed fibreglass (height 61) EXH: NAC 1962 (109). Collection Mr and Mrs Boar

Water Reeds

Oil on board (23 x 28) INSC: lower left Wilfred Pettit.
Private collection, Judy Hines Art Gallery, Fish Hill, Holt

Wilfred Stanley Pettitt 1904–1978

Born in Great Yarmouth. Studied at Great Yarmouth and Norwich Schools of Art. In 1929 he moved to Norwich, where he worked in the advertising department of the Norvic Shoe Company and retired as manager in 1969. A founder member of the Norwich Twenty Group and Secretary 1946–8 and later Chairman 1953–4 of the Art Circle. Exhibited at the RA 1928–48, RBA and the Royal Cambrian Academy. In the 1920s he began experimenting in woodcuts and etchings, but he was mainly an East Anglian landscape painter in oil, although he also occasionally painted portraits. He was a protégé and friend of Arnesby Brown.

Horstead Mill

(Henry James Starling)
(21 x 31) INSC: lower right. Private collection Mr Ray Shreeve

Henry James Starling 1905–1996

Born in Norwich. Studied part-time at Norwich School of Art under Charles Hobbis and Horace Tuck. On leaving school he became a trainee at Colman's Printing Works, retiring as Works Director in 1970. While at Colman's he taught himself lithography and etching. He became a very accomplished etcher and in 1956 was elected an Associate of the RE. Also exhibited at the RA 1935–62 and in exhibitions in Norwich. Chairman of the Art Circle 1947–9 and served as Chairman of the Board of Governors of Norwich School of Art. In addition to etching, he also painted in watercolour, views of Norwich, East Anglia and Italy.

Leslie Davenport 1905–1973

Born in Harrow. Studied at Harrow School of Art and the Royal College of Art. Taught painting at Schools of Art in Oxford, Barnstaple and Bideford, and during the Second World War served as an aircraft inspector. In 1944 joined the staff of Norwich School of Art where he remained until his retirement in 1971. 'Dav' was a founder member of the Norwich Twenty Group and of the Norfolk Contemporary Art Society. Exhibited at the RA 1947–65, the NEAC, the RI, the London Group and in various other exhibitions in London and the provinces. He worked in oil and crayon and occasionally in watercolour, and is noted for his pictures of building construction and demolition. Following his death, a book was published of his pictures of Norwich buildings, *Davenport's Norwich*, Wensum Books, 1973.

Peafield Mill
(Leslie Davenport)
1969 oil on board (55 x 70) Collection of Marjorie Carlton

The Pylon, Yarmouth Harbour
1949 oil on canvas (40.7 x 50.7) INSC: lower right
E.S. HINES. Private Collection Judy Hines Art Gallery,
Fish Hill, Holt

Edward Hines 1906–1975

Born and lived throughout his life in Norwich. Became a Director of a family engineering business in Norwich and did not begin painting until after the Second World War. Chairman of the Art Circle 1963–4, and exhibited for many years at the ROI. A traditional outdoor landscape painter, he worked mainly in oils and gained much experience from painting trips with Campbell Mellon and Rowland Fisher. He was also well acquainted with Arthur Davies and Wilfred Pettitt.

Leslie L.H. Moore 1907–1996

Born in Norwich. Studied at Reading University and Norwich School of Art, where he later taught general subjects in the Junior Art Department. Also taught at the Hewett School, Norwich. A member of the Norwich Twenty Group. Exhibited with the RI, of which he was elected a member, at the RA from 1948, the NEAC and also various other exhibitions in London and the provinces. He lived at North Walsham. An East Anglian landscape painter in watercolour, many of his pictures have been used to illustrate books and other publications.

Wells
1973 watercolour (36.5 x 54.5). Private Collection
Peter Moore

Marjorie I. Porter 1908–

Born in Deeping St Nicholas, near Spalding, Lincs. Studied at Norwich School of Art under Charles Hobbis and Horace Tuck. She was encouraged by Charles Hobbis to specialize in animal painting and so studied at the Lucy Kemp-Welch School of Animal Painting and at the St John's Wood School of Art. Exhibited at the RA, the Paris Salon, RI, Royal West of England Academy and in the provinces. In addition she frequently exhibited with the Pastel Society and in the early 1950s was invited to become a member. She worked in pastel and was well known for her animal portraits, although she also exhibited flower pieces and landscapes.

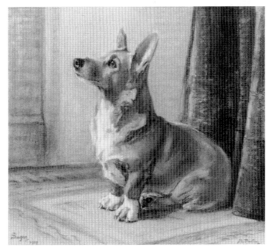

Susan
1957 pastel (sight, 40.7 x 52.1) INSC: lower left Susan/1957; lower right M. Porter. Private Collection H.M. The Queen

Sugar
1957 pastel (sight, 45.7 x 50.2) INSC: lower left Sugar/1957; lower right M. Porter. Private Collection H.M. The Queen

Morning Haze, West Somerton
1973 egg tempera on board (25.2 x 35.5) INSC: lower right NOEL DENNES. Judy Hines Art Gallery, Fish Hill, Holt

Noel Frank Bevan Dennes 1908–1988

Born in Lowestoft. Studied part-time at Norwich School of Art and under the landscape painter Ernest Whydale. Exhibited at the RBA, RI, RE and the National Society of Painters, Sculptors and Engravers, as well as in the provinces and one-man shows in Norwich. Served as Chairman of the Art Circle, and was Vice-President from 1981. A printmaker and painter mainly of East Anglian landscapes, he worked in oil and watercolour and more latterly in tempera.

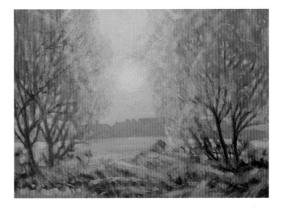

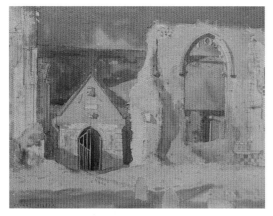

Covehithe Church, Suffolk
1967 pencil and watercolour (28.5 x 38.5) INSC: lower left STUART MILNER. Private Collection Mr and Mrs Andrew Anderson

Winter Landscape
Oil on canvas (49.5 x 75). Norwich Castle Museum and Art Gallery. By kind permission of the Trustees of the Estate of Edward Seago. Courtesy of Thomas Gibson Fine Art

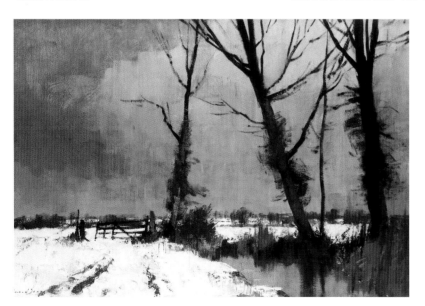

Stuart Milner 1909–1969

Born Thomas Stuart Milner in South Essex. Studied at the Central School of Arts and Crafts, and at Regent Street Polytechnic 1926–9. Worked as an interior decorator and furniture designer in London before moving to Norfolk to concentrate on painting. During his time in Norfolk he also worked as a picture and furniture restorer and painted heraldic devices. Virtually self-taught as an artist. Exhibited with the RBA and RWS and was elected a member of both, and also exhibited at the RA 1933–51, the Paris Salon, Scotland and the provinces, including several one-man shows in Norwich. At the time of his death he was living at Thrandeston, Norfolk. A landscape painter in oil and water-colour, he also occasionally painted still lifes and portraits.

Edward Seago 1910–74

Born in Norwich, the son of a coal merchant. He was a sickly child from the age of seven when he developed a heart defect. Confined to bed he painted from his window. He was discouraged from this by his parents whose ambitions were for him to go into business. He was therefore, virtually self-taught as an artist, although he did receive some instruction at the Royal Drawing Society and from Bertram Priestman. He exhibited with the Art Circle from 1926–32, when both Arnesby Brown and Munnings were active in the Circle, exhibiting and guiding in their capacities as Presidents. It is therefore unsurprising that Seago followed in their wake, developing as a landscape painter. His contacts led him into exalted company and he indulged in what would now be called networking. At the age of eighteen he joined a travelling circus and spent several years touring Britain and Europe. These tours provided him with material for his pictures and for two books on circus life which he published in 1933 and 1934. He also published several books with John Masefield. During the Second World War he served with the Royal Engineers, but was invalided out in 1944 and was invited by Field-Marshall Alexander to record the Italian Campaign. In 1953 he was appointed one of the official artists for the Coronation and in 1956 accompanied the Duke of Edinburgh in *Britannia* on a round-the-world trip, which included Antarctica. Prince Charles was said to be 'totally captivated by the unique way he could convey

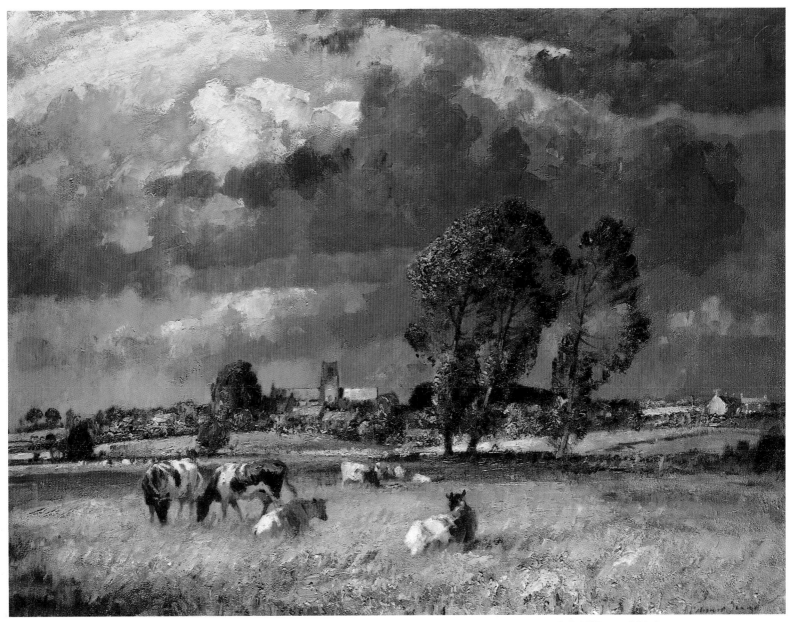

Norfolk Village, Aldeby
Oil on canvas (75.9 x 101.5) Norwich Castle Museum and Art Gallery. By kind permission of the Trustees of the Estate of Edward Seago. Courtesy of Thomas Gibson Fine Art

atmosphere on canvas'. Was invited to paint at the Queen Mother's Scottish home but she retained his work as recompense for board and lodging. During his life he travelled extensively on the Continent and also visited Africa and the Far East. Exhibited widely, including the RA 1930–59, ROI, RBA and RWS, and also with the IFAC. Elected RBA 1946 and RWS 1959. He worked in oil and watercolour, and in addition to landscapes of East Anglia and of his foreign travels, he painted scenes of circus life, the ballet and flower pieces. In spite of moving in these elite circles, critics said that he had failed to develop. His style was passing from artistic fashion just as that of Arnesby Brown and Munnings had. He lived for many years until his death at Ludham, Norfolk.

East Window

Oil on hardboard (48.8 x 37) Norwich Castle Museum and Art Gallery. By kind permission of the Trustees of the Estate of Edward Seago. Courtesy of Thomas Gibson Fine Art

Henley G. Curl 1910–1989

A solicitor by profession. Began painting as a young man during a long illness and received encouragement from Horace Tuck. Over several years attended the East Anglian School of Painting and Drawing run by Cedric Morris and Arthur Lett Haines, first at Dedham and then at Hadleigh. Although he had painted in oils, he soon decided to concentrate on watercolour painting. Exhibited at the RA 1947–8, the RI, Law Society exhibitions and various other exhibitions in London and Norwich. A founder member of the Norwich Twenty Group and the Norfolk Contemporary Art Society. He was actively involved in the Art Circle, holding various offices, and was also a generous patron of Norwich Castle Museum.

VE Night, Norwich
1945 pencil and watercolour (37.5 x 28.7) INSC: lower left H.G. Curl '45/V.E. Night. Norwich Castle Museum and Art Gallery, presented by the artist 1985 (1.217.985)

Jean Alexander 1911–1994

Born in Shenfield, Essex, the youngest of five children to parents Robert and Effie who were both artists of ability. She studied at Chelmsford School of Art 1928–1931 and the Slade 1931–1935. She taught at Brentwood County High School, becoming head of art until retirement in 1970. From 1970–74 she lived in New Zealand, where she continued to teach, before returning to the UK to live at Thelverton, Nr Diss. Her inspirations were Hercules Brabazon Brabazon and under the influence of her father the french impressionistic style of Mark Fisher RA. Robert and Jean were both Slade students and pupils of Philip Wilson Steer. Her greatest influence was her painting partner of the thirties, Sir George Clausen RA, and it was at that time she developed her bold, simple and experimental style. She has exhibited at the RA, the New English Art Club and Society of Women Artists.

Home on Leave

(Jean Alexander)

Oil on board (50 x 61) Private collection, Judy Hines Art Gallery, Fish Hill, Holt

Cavendish Morton b.1911

Born in Edinburgh. Studied art under his father, who was a theatre director, actor and photographer. He spent the war in the aircraft industry. Settled in Suffolk in 1949 and for many years lived in Eye, twice becoming town mayor. He married Rosemary Britten musician and music teacher in 1946. They have one son and two daughters. He taught art at various schools in East Anglia and also made a series of programmes on painting for Anglia TV in 1960. He was actively involved in promoting contemporary art in East Anglia and was a founder member of the Norfolk Contemporary Art Society, a member of the Norwich Twenty Group and served on the original steering committee of the Eastern Arts Association in 1972. He has also been involved in various other art organisations in Norfolk and Suffolk. He has exhibited widely and was elected a member of the RI and ROI and has also exhibited at the RA 1930–67, RBA, NEAC and in Scotland and the provinces, including the IFAC. He works in oil and watercolour and paints landscapes, industrial and marine subjects and, following an illness in 1967, flower subjects. He also did a series of paintings of Snape Maltings Concert Hall.

Nunwell Farm, Winter Landscape
(19 x 25) INSC: lower right Cavendish Morton. Private Collection. By kind permission of the artist

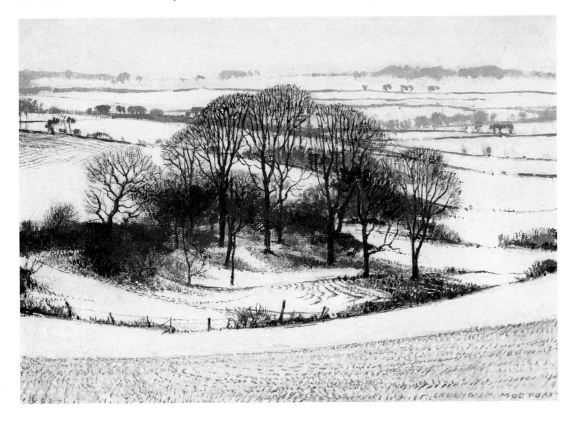

Broken Light, Bembridge Marshes
2001 watercolour (22 x 34) INSC: bottom right Cavendish Morton. Private Collection. By kind permission of the artist

In 1977 he moved to the Isle of Wight. Work in collections: British Museum; Norwich Castle Museum; Wolverhampton Art Gallery; Contemporary Art Society; Eastern Arts Association; Suffolk Education Authority; Isle of Wight Museums; Gustave Holst Museum, Cheltenham; National Trust; Royal Naval Museum, Portsmouth; and others. Technical illustrator for the *Sphere* (now defunct), of aircraft, shipping, motor cars, motor racing, engineering, etc.

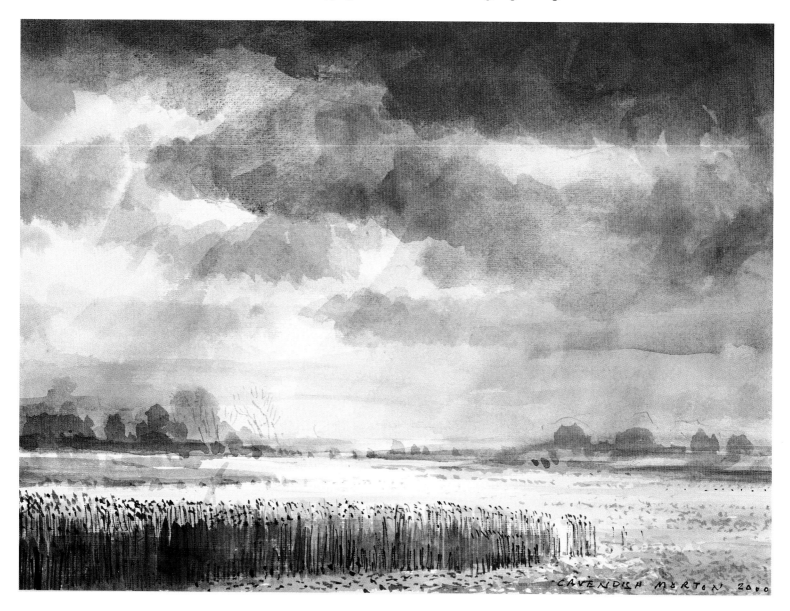

Geoffrey Wales 1912–1990

Born in Margate. Studied at Thanet School of Art 1929–33 and the Royal College of Art 1933–7 under Malcolm Osborne, Robert Austin, John Nash, Eric Ravilious and Edward Bawden. Taught at the Canterbury Group of Art Schools 1937–53 and then at Norwich School of Art until his retirement in 1977. Served in the RAF during the war and is a former Chairman of the Norwich Twenty Group. An accomplished wood engraver, he has exhibited at the RE and was elected a Fellow in 1961. Many of his engravings have been used to illustrate publications.

Beach Huts
(Geoffrey Wales)
Collage (14 x 13) Private collection, Judy Hines Art Gallery, Fish Hill, Holt

James Fletcher Watson b.1913

Born at Coulsdon. Studied at the Royal Academy School of Architecture. Worked as an architect for several years in Norfolk before moving to Gloucestershire. Elected an RI 1955 and RBA 1957 and also exhibited at the RA 1943–61 as well as in the provinces and abroad. An architectural and land-scape artist in watercolour, he received an Honourable Mention at the Paris Salon for a picture of Norwich Cathedral.

Junk Shop Cow Hill

Watercolour on board (51 x 48) INSC: lower left F J Watson. Private collection, Judy Hines Art Gallery, Fish Hill, Holt

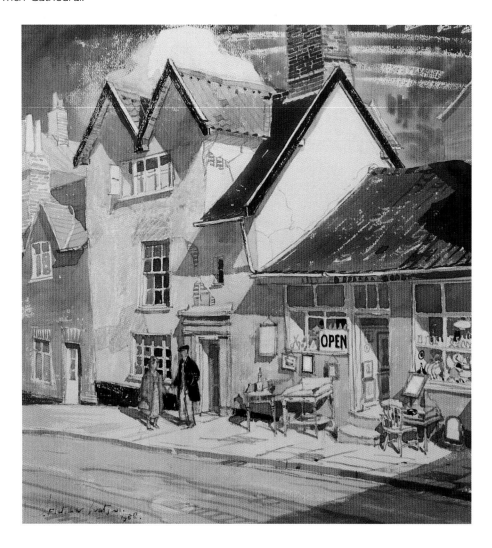

Bernard Reynolds 1915

Sculptor. Born in Norwich. Studied at Norwich School of Art 1932–7 at the same time as Bernard Meadows and was also invited to become one of Henry Moore's assistants, frequently visiting the sculptor's studio. 1937–8 studied at Westminster School of Art. Worked as a naval instruments engineer in Norwich 1938–47. Taught for a year at Sheffield School of Art and from 1948 at Ipswich School of Art. Retired from full-time teaching in 1981. Founder member of the Norwich Twenty Group, member of Colchester Art Society and in 1971 was elected a member of the Royal Society of British Sculptors. Exhibited in various one-man shows in East Anglia, most notably a retrospective touring exhibition sponsored by Colchester Art Society 1984–5, and group exhibitions in London and East Anglia, including the RA 1946 and IFAC since 1950. His work is represented in various private and public collections in Britain and abroad.

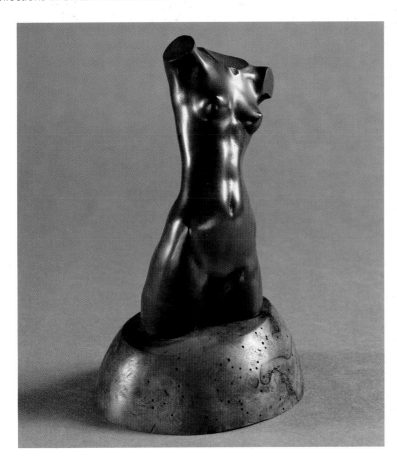

Torso bronze on walnut base
(23 x 14.7 x 12.2) INSC: incised on back of right leg Reynolds. Norwich Castle Museum and Art Gallery, presented by Mrs M.L. Byers 1947 (64.947)

Bernard Meadows 1915

Sculptor. Born in Norwich. Worked in an accountant's office, but left after two years to become a student at Norwich School of Art 1934–6, when he studied painting. Later studied at Chelsea School of Art 1936–7 and the Royal College of Art 1938–40, 1945–7. Studio assistant to Henry Moore 1936–9. Served in the RAF during the Second World War and returned to teach at the Royal College of Art and Chelsea School of Art, becoming Professor of Sculpture at the Royal College in 1960. He has had many one-man shows in Britain and abroad, including a joint exhibition with Michael Andrews in Norwich in 1964, and his sculpture has been included in various other group exhibitions. An internationally recognised sculptor, his work is represented in collections throughout the world. In Norwich there is a commissioned work outside the entrance to Eastern Counties Newspapers' office, and in college courts at Cambridge. Drawings and sculptures are also in the collection at the Sainsbury Centre, UEA, Norwich.

Standing Armed Figure
1962 bronze (54.7 x 31.5 x 18) edition 5/6 INSC: on back of base incised with M in a circle. Norwich Castle Museum and Art Gallery, on loan from the Norfolk Contemporary Art Society 1963 (272.963)

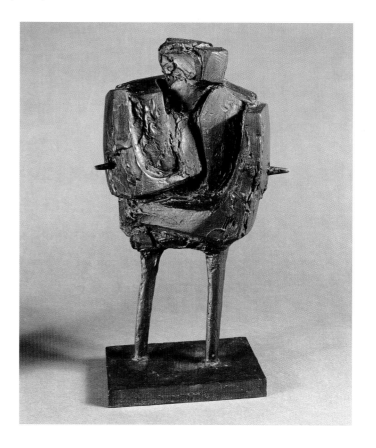

Marion Trim 1918–1987

Studied at Southampton School of Art 1934–8, specialising in wood engraving, and 1938–9 at London University Institute of Education. Taught art in Walsall and Cambridge. In 1968 moved to Norwich, and in 1973 began to study etching and screenprinting. A member of the Norwich Twenty Group, she has exhibited her work in East Anglia.

Edward Barker 1918–1983

Sculptor. Born in Norfolk. Studied at Norwich School of Art. Exhibited in group exhibitions in London and East Anglia and one-man shows in Holland, Norfolk and Suffolk. Work represented in public collections in Delft, Ipswich and Norwich, including a commission for six panels in relief for the offices of John Mackintosh & Sons, Norwich, 1955. A member of the Norwich Twenty Group. Taught sculpture part-time at Norwich School of Art and at summer schools he ran with his wife Ruth Barker at their home in Newton Flotman.

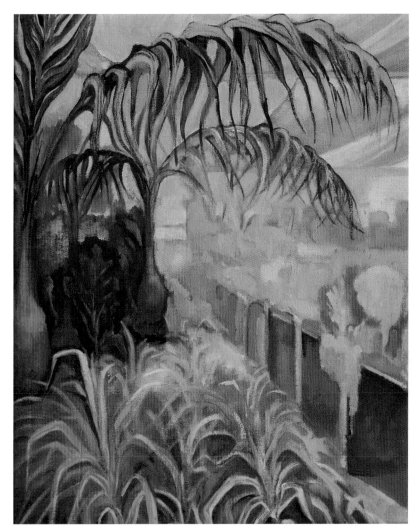

Above: **The Greenhouse**
Oil (56 x 46) Collection of Mr A.R. Trim

Left: **Diana**
1972 sculpture (22 x 16) Private Collection Mrs Ruth Barker

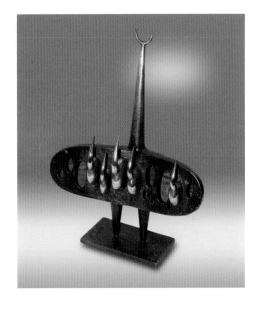

Mary Newcomb b.1922

Born in Harrow. Studied natural sciences at Reading University and later taught science and mathematics in Somerset until 1950, when she moved to Norfolk. She received no formal training in art, although as a science student she learned to draw by direct observation. As her husband made pots in his studio, Mary would paint whatever she saw from her window. Her work has been exhibited in various group exhibitions and in one-woman shows in Britain and abroad. A member of the Norwich Twenty Group, she now lives in Newton Flotman. Her oil paintings, patterns of subtle colour, have been described as 'sophisticated naive paintings' and her subjects are taken from everyday life. She has a child's naive fascination with the details of life that others dismiss as unremarkable. Iris Francis President of the Circle in 2001–3, ran an art school postwar, and Mary taught there at one time.

The Fête
1976 oil on hardboard (61 x 58.5) INSC: lower right Mary Newcomb. Norwich Castle Museum and Art Gallery, purchased with the aid of a grant from the Victoria & Albert Museum 1978 (128.978)

William Hartwell 1922–1995

Born in Warwickshire. Studied at Goldsmiths' College, London, but this was interrupted by the Second World War, during which he served in India and Burma. After the war studied at Norwich School of Art. Exhibited in various exhibitions in London, including with the London Group, and also in Norwich and at the Aldeburgh Festival. A member of the Norwich Twenty Group and taught art at schools in Norwich. He worked in oil, watercolour and gouache and his work was purchased by the Contemporary Art Society.

Ronald Courteney b.1922

Studied at Norwich School of Art 1947–51 and Bournemouth School of Art 1951–2. Exhibited with the RBA 1954–73, the RA, National Society and in various exhibitions in East Anglia. Served as Chairman of the Art Circle in 1972 and is also a member of the Norwich Twenty Group. A landscape painter in oil and watercolour, his work is represented in public and private collections in Britain and abroad. Now living in New Zealand where he sells only a couple of works a year but hires his work to companies on a monthly rate.

River Wensum at Night
1954 watercolour (39.2 x 52.2) INSC: lower centre WH 54

Looking for Luke
(Ronald Courteney)
Oil on canvas (76 x 96.5) By kind permission of the artist

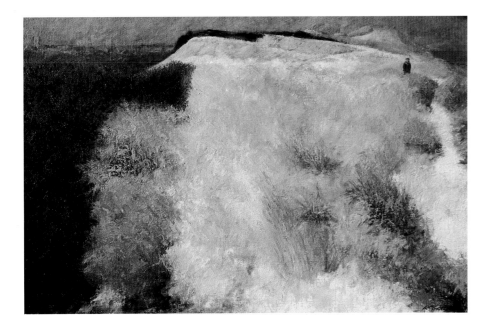

85

Untitled
(Gwyneth Johnstone)
Oil (15.5 x 19.5) Private Collection

View of village Eye, Suffolk
(Jeffery Camp RA)
1943/4 oil on board (64.7 x 165) Courtesy Browse & Darby

Gwyneth Johnstone b.1922

Born in London. Studied in Paris at the Andre Lhote School and at the Central School, London, under Cecil Collins. Divides her time between Alicante and Norfolk, which inspires much of her work, and also works in London and the South of France. Exhibited with the Young Contemporaries, the London Group, Women's International Art Club, in which she served as Vice-President, and has had regular one-woman shows in London galleries and in Spain and America. A contemporary painter of landscapes and village life in oil, her work has been purchased by various local authorities and institutions, including the Contemporary Art Society.

Jeffery Camp RA b.1923

Born at Oulton Broad, Suffolk, the only son of a cabinet maker and antique dealer. Studied at Lowestoft and Ipswich Schools of Art and under William Gillies at Edinburgh College of Art 1941–4. Taught at Norwich and Lowestoft Schools of Art in the 1950s. In 1955 he was commissioned to paint

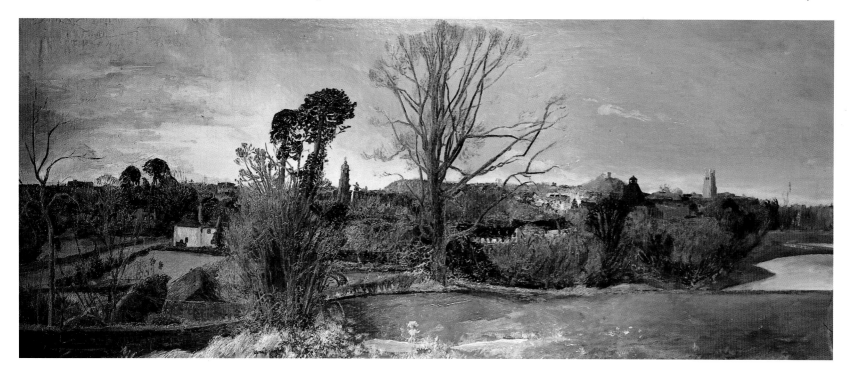

the altarpiece for St Alban's Church, Lakenham. Towards the end of the war on his return to his parents' home in Suffolk, he began painting landscapes, the trees through the seasons. As a landscape painter, he was eligible for a bursary which involved showing his work to Sir Alfred Munnings, then President of the RA. Munnings was critical, commenting on his 'bottle green' and recommending that he get out and paint 'thorn bushes'. Munnings showed him around the Academy, throwing open doors in a lordly proprietorial way. There was no meeting of minds, Camp wanting to paint like Bonnard and Matisse. All the same, he was awarded the bursary. He taught at the Chelsea School of Art 1960–61 and the Slade School of Art 1963–88. Elected a member of the London Group in 1961 and an Associate of the RA in 1974. Elected Royal Academician 1984. In the late 1960s he moved to Hastings with his wife, the artist Laetitia Yhap. Phillips Prizewinner 1965. 1981 wrote *Draw* and 1996 wrote *Paint*, both published by Dorling Kindersley. An internationally recognised artist, his work is represented in many public collections, including the Arts Council, the Tate Gallery, the Royal Academy of Arts, The British Council, University of London, Norwich Castle Museum, The Nuffield Organisation, London Transport and others. Selected Exhibitions: 1950 Edinburgh Festival; 1959/60/61 Beaux Arts Gallery, London; 1978 Serpentine Gallery, London; 1984, 1993, 1997, 2001, Browse & Darby, London; and others. He paints what he likes and the titles reflect his favourite places and people. Some of his recent works are tiny, down to 7 x 9cm.

Ruth Barker b.1925

Born in Norwich. Studied Fine Art at Reading University. From 1948–55 Assistant Keeper of Art at Norwich Castle Museum. For several years she and her husband, the sculptor Edward Barker, ran an annual summer art school at their home in Newton Flotman. Also taught part-time at Norwich School of Art and Norwich City College and from 1966 has been a full-time art teacher at schools in Norwich. A member of the Norwich Twenty Group of which she is a former Chairman and Secretary.

Caravan at Mary Newcomb's Farm
(Ruth Barker)
1956 oil on board (61 x 46) Private Collection

Michael Andrews 1928–1995

Born in Norwich. Attended part-time classes in oil painting under Leslie Davenport at Norwich School of Art. From 1949–53 studied at the Slade School of Art, winning the Rome Scholarship in painting in 1953. Taught at Norwich School of Art 1959, Chelsea School of Art 1960–61 and the Slade School of Art 1963–66. A member of the London Group which included Jeffery Camp, Peter Blake, Patrick George and Lucian Freud, who painted Michael's portrait. His modern landscapes emit a sense of detachment, an alienation from the world and feelings rather than the pretty exuberances of Seago and his predecessors. His work has been included in various exhibitions in London as well as several one-man shows, most notably an Arts Council Retrospective Exhibition, London, Edinburgh and Manchester 1980–81. An internationally recognised artist, his work is represented in public and private collections in Britain and abroad. He returned to live in East Anglia in 1977 settling in Saxlingham Nethergate.

Painter at Work

c.1957 oil on canvas (25.3 x 30.2) Collection Marjorie Carlton

The painting shows the artist Leslie Davenport at work in his garden in Thorpe Road, Norwich. In the foreground is a sculpture by Jeffery Camp. Michael Andrews gave this unfinished sketch to Leslie Davenport.

Bennett Oates b.1928

Born in London, he attended grammar school then studied under Gerald Cooper at Wimbledon College of Art, from where with Gerald's encouragement, he had his first flower painting hung at the Royal Academy at the age of fifteen. He went on to gain a scholarship to the Royal College of Art. Bennett has a broad interest in painting and examples of his landscapes, portraits and animals are to be found in many private collections. However, it is his flower paintings that have made his reputation. He is recognised as being one of the finest painters now working in this genre and his style is comparable to the Dutch School, but he uses gentler English hues with jewel-like strong colours in conjunction with white and pastel shades. He believes that worthwhile art is founded on craftsmanship and technique. President of Guild of Norwich Painters.

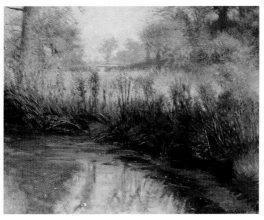

Above: **Landscape**
Oil on panel (51 x 61) INSC: lower right Bennett Oates. Annual exhibition of Guild of Norwich Painters, Westcliffe Gallery, Sheringham

Left: **Flower piece**
Oil on panel (48 x 54) INSC: lower right Bennett Oates. Annual exhibition of Guild of Norwich Painters, Westcliffe Gallery, Sheringham

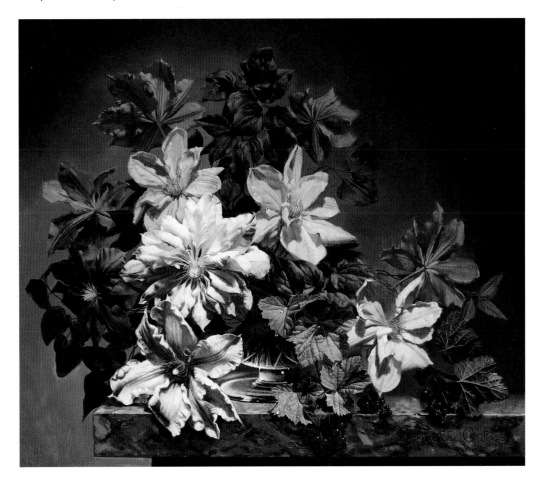

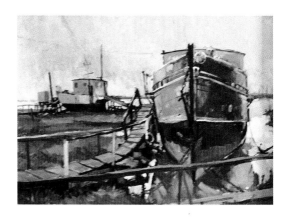

Above: **Semprini's Boat**
(Albert Ogden)
Oil on canvas (57 x 72) Permission of the artist

Albert B. Ogden b.1928

Born in Blackburn, Lancashire. Studied at Blackburn School of Art and at Leicester and Cardiff Colleges of Art. Moved to Norwich to become lecturer in painting and Head of Art at Keswick Hall College of Further Education. A former member of Norwich Twenty Group and Chairman of the Art Circle 1971. He has exhibited in group exhibitions and one-man shows in Norwich, King's Lynn, Luton, Cardiff, the Stern Gallery, Austria, and Kendal, and his work is included in public and private collections in Britain, Europe and America. He now lives and works in Wray near Lancaster.

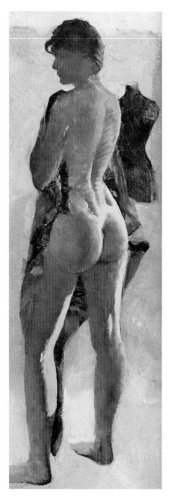

The Dressmaker
(Anthony Dalton)
Oil on board (39 x 15) Private Collection

Anthony Dalton b.1929

Born in Leicester, he was educated from the age of 13 at Southend-on-Sea School of Art, followed by a three year apprenticeship in illustration in London. 1950–52 Illustrator with Gilchrist Studios, High Holborn. He then became a freelance illustrator and Corporate designer: 1958 elected to SIAD. 1958–68 teaching at Southend School of Art as a part time lecturer teaching illustration and graphic design. 1968–78 at Soman-Wherry Press as Design Director and appointed to the board in 1972. Fellow of SIAD 1978. Appointed graphic design consultant to University of East Anglia 1979–1990. Industrial Advisor to University of London 1981–1990. Managing Director AD Creative Design and Advertising 1982–1990. Governor Southend College of Technology 1983–85. Governor Great Yarmouth College of Art and Design 1983–1988. Governor of the Norfolk and Norwich Institute of Art and Design 1988–1989. Anthony paints portraits, nudes and marine landscapes in watercolours and oils. Exhibitions in Fairhurst Gallery, Norwich, and Westcliffe Gallery, Sheringham. Pictures in the Colman's Collection and in Norwich Castle Museum a portrait of Reverend David Clark, Sheriff of Norwich, 1981–2. The painting 'Sunset, Burnham Overy Staithe', achieved the highest price paid in an NNAC exhibition, 1990.

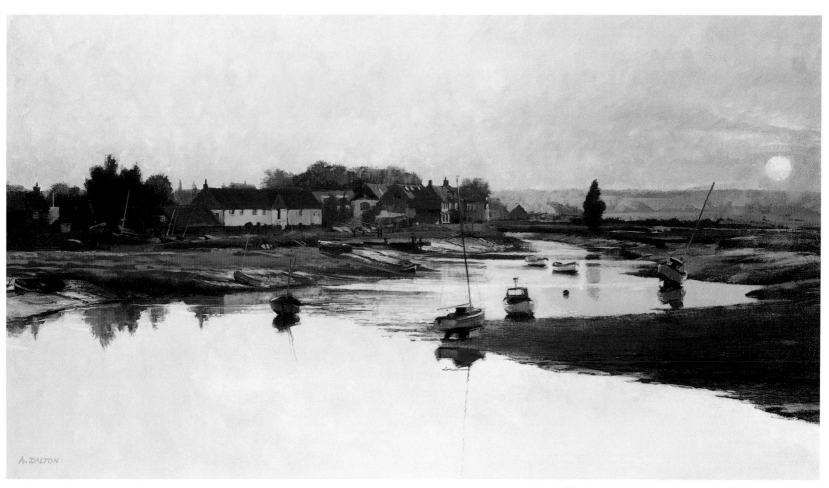

Sunset, Burnham Overy Staithe
(Anthony Dalton)
1990 oil on board (41 x 90) Private Collection

Keith Johnson b.1931

Born in Norfolk. From 1946–51 attended Norwich School of Art, where his studies were interrupted by national service in the RAF. During the latter part of his time at the School of Art he specialised in fabric printing and weaving which was to have a lasting effect on his work by heightening his colour awareness. Taught at Lowestoft School of Art in 1951 and for four years in secondary schools. This was followed by a two years teachers' exchange in Canada and since his return to Norwich in about 1960 he has taught in various schools. Exhibited at the ROI, RBA and the RI and in 1982 at the RA Summer School. A landscape painter, he works in oil and watercolour, and his early childhood on a farm has had a lifelong influence on his work. The picture 'Turn of the Year' was shown at the NEAC 1997.

Turn of the Year
(Keith Johnson)
Oil on board (28 x 24) Permission of the artist

Jean Morris b.1931

Diploma Manchester Art School, Diploma Bangor College of Education, Hons. Degree Fine Arts, UEA, 1986. Taught art part-time in various secondary schools as her husband's work moved him around the country. Finalist Channel 4 television's Watercolour Challenge 2000, the final taking place at Highgrove, the Prince of Wales' residence. HRH retained the finalists' paintings. Mall Gallery 2000.

The Docks
2000 watercolour (51 x 38) INSC: bottom right Jean Morris. This painting won the watercolour challenge competition mentioned above. By kind permission of the artist

William Arthur Goulding b.1932

Born in Bradford, Yorkshire to a musical family. His ambition was to be a concert pianist but the family circumstances did not allow for the tuition necessary. He joined a theatrical company touring the UK in variety and revue, then became in order, resident pianist at the Dorchester Park Lane, The Ritz Piccadilly, The Hampshire Hotel, Leicester Square, and other prominent venues. He was interested in painting and drawing from childhood. He is a self taught 'naive' painter with a wry sense of humour and is an admirer of Charlie Chaplin who has featured in some of William's paintings. Exhibitions: Paris Salon, Champs-Élysées 1965, 1970, 1972, 1973, 1975; Lugano 1970; Lancaster Gallery (one work purchased by Manchester University); Salford Art Gallery (two works purchased by Manchester University); Bluecoat Gallery, Liverpool; Grosvenor Gallery, London; Royal Society of British Artists, The Mall; Royal Academy Summer Exhibition, London, 1974, 1982, 1992, 1993, 1997.

Can't you hear
1975 oil on board (41 x 51) INSC: lower left W.A. Goulding. Chosen by L.S. Lowry for Manchester University Collection

Geoffrey Lefever b.1932

Born in London. Moved to Norfolk in 1963 and now lives at Aylsham. Studied at Norwich School of Art 1981–4. A member of the Norwich Twenty Group and the Norwich Artists. Exhibited in France, London and the provinces and has had various one-man shows, most notably at the Thackeray Gallery, London,1971 and 1973, and the Pottergate Gallery, Norwich, 1974. A contemporary landscape painter in oil and watercolour, much of his work has been inspired by the East Anglian countryside and visits to South Wales and Arles in France. His more recent work has become increasingly abstract with an added collage element.

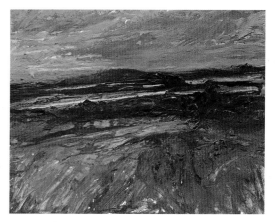

Above: **Dersingham in Winter**
(Geoffrey Lefever)
Oil on board (66 x 91). Permission of the artist

Left: **En Vacances**
(Pauline Plummer)
1993 oil pastel on board (45.7 x 35.6). Permission of the artist

Pauline Plummer b.1933

She attended University of Reading 1951–55 obtaining a BA Hons. Fine Art, specialising in drawing and painting. 1955–59 Pilgrim Trust studentship for the study of the conservation of paintings, administered by the Council for the Care of Churches, spent at the Courtauld Institute of Art and elsewhere. Since then she has worked as a conservator of paintings and polychromy. Among clients have been churches, cathedrals, museums, local and county councils, schools, universities, stately homes, charitable trusts, English Heritage and the National Trust. Exhibitions: ROI, RBA; 1991 Laing Collection, Ipswich; 1994 Pastel Society, Mall Galleries; 1995 Pastel Society, Mall Galleries; 2001 The Society of Landscape Painters, Mall Galleries; 2002 Pastel Society, Mall Galleries. Distinctions: Fellow of the Society of Antiquaries; Fellow of the Institute for the Conservation of Artistic and Historic Works; Fellow of the Association of British Picture Restorers; Accredited Conservator United Kingdom Institute for Conservation.

Michael Woods b.1933

Educated at the Norwich School, Norwich School of Art, the Slade School of Fine Art, University College, London. (Professor Sir William Coldstream; Tutor Sir Thomas Monnington PRA.) He won Prize for Anatomy 1955; Chairman Young Contemporaries 1956–57; Diploma in Fine Art 1957. Joined the staff of Charterhouse, Surrey 1957; Director of Art Charterhouse 1970–94 – teaching drawing, painting, anatomy, stage design, ceramics and history of architecture. Also tutor for Open College of Arts. Michael has work in the collections of the Nuffield Foundation, the National Trust at Berington Hall and City of Norwich Castle Museum. Commissioned portraits of Lord Cawley, His Honour Judge John Bull, QC, The Rt Reverend Peter Nott, Bishop of Norwich, and others. As a potter, sometime exhibiting member of British Crafts Centre, listed by the Crafts Council. Designer, Historic map of Godalming for the Godalming Trust; Memorial at Dachau Concentration Camp for the International Committee. Illustrator of ten books including, *Roman Crafts* by Donald Strong and David Brown and *The Turkomen Carpet* by George O'Bannon. Commissioned reviews and articles, including *Artist and Illustrator* magazine. Author: *Mounting & Framing Pictures* 1978; *Perspective in Art* 1984; *Starting Pencil Drawing* 1987; *Starting Life Drawing* 1987; *Picture Framer's Handbook* 1989; *Starting Landscape Drawing* 1989; *The Complete Drawing Course* 1995; *Drawing Techniques* 2000; *How to Keep a Sketch Book* 2002.

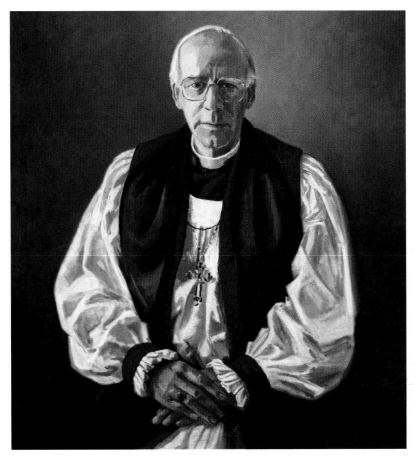

The Rt Reverend Peter Nott, Bishop of Norwich
1999 oil (101 x 91) INSC: bottom left Michael Woods. The Granary Court, Bishop's House. By kind permission of the artist

Geoffrey Burrows b.1934

Born in St Faiths, Norwich, the son of an automobile engineer. He was educated at Paston Grammar School. He had no formal art training, but began painting seriously after attending a class at Sprowston School. Geoffrey became a Telecomms engineer on leaving school and retired as manager in 1991. He paints mainly in Norfolk and France but has also painted in Germany, Switzerland, Italy, Hong Kong, India, Thailand and the USA. He has an impressionistic style using a limited 'Northern European' palette. As well as the NNAC, he belongs to the Bury St Edmunds Art Society and the

East Anglian Group of Marine Artists. His favourite subject remains Southern France, the beaches and environs of the Languedoc with the backdrop of the Pyrenees. He has works in the permanent collections of Atkinson AG Southport and Norwich Union. Exhibitions: Royal Academy Summer Exhibition 1980–1996 & 2000; RBA 1981–1991; ROI 1981–1989 & 1993–2001; NEAC 1988 & 1991–2001; RI 1983–1985 & 1988; Royal West of England Academy 1993–1994; Paris Salon 1987–1989; Llewellyn Alexander 1994–2001. Various mixed exhibitions here and on the Continent.

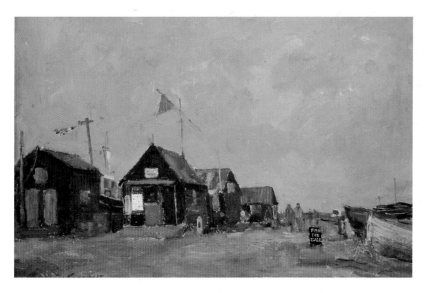

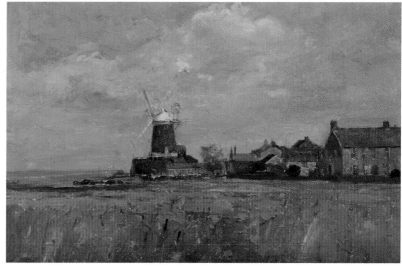

Above left: **Fish for Sale, Southwold**
Oil on board (20 x 31) INSC: lower left Geoffrey Burrows. Kind permission of the artist

Above: **Cley Mill**
Oil on board (24 x 36) INSC: lower left Geoffrey Burrows. Kind permission of the artist

Left: **Back Street, St Faiths**
Oil on board (51 x 61) INSC: lower right G.N. Burrows. Kind permission of the artist

Ian Houston b.1934

Born at Gravesend, Kent. In 1950 he began full-time studies at the Royal College of Music, London and subsequently part-time at St Martins School of Art. He began exhibiting in London in 1956. First solo exhibition at the Usher Gallery, Lincoln. He met Edward Seago (NNAC member) in 1956 from whom he received encouragement and ongoing training. Under Seago's influence, he moved from wildlife painting to landscape. He moved to Norfolk, becoming music teacher at North Walsham High School for Girls. 1970 first exhibited at Mandell's Gallery, Norwich. In 1974 he bought the seagoing Thames spritsail barge, *Raybel*, subsequently gained his Master's certificate in order to study sea, weather and traditional sail in action. Other exhibitions: 1984 he had his first one man exhibition in Australia (Victoria Art Society, Melbourne); 1995 The Portland Gallery, London; The Museum Annexe, Hong Kong; 1996 Edinburgh Festival Exhibition; 1997 The Portland Gallery, London; 1999 The Portland Gallery, London; 2001 Edinburgh Festival Exhibition; Coast and Sea, Portland Gallery, London. Annually at Mandell's Gallery, Norwich. ARCM FRSA. Collections: HM The Queen; HRH The Duke of Edinburgh; The Australian Government; The State Bank of South Australia; Barclays Bank PLC; Batey Burn, Hong Kong; Cater Allen Holdings; Mercury Asset Management; Norwich Union; Robert Fleming Holdings Ltd; The Usher Gallery, Lincoln; Winsor and Newton. Awards: 1976 Silver Medal, Paris Salon (watercolour); 1983 Gold Medal with Rosette, National Soc. Of French Culture; 1996 Paul Harris Fellowship, Australia. Commissions etc.: 1984 Wrote and performed score for Puppet Theatre production, Melbourne; 1987 Official artist and sponsor for STS Young Endeavour; 1989 Presentation of picture to HM The Queen by Company of Watermen and Lightermen marking 400th Anniversary; 1999 Sponsored visit to Falkland Islands by Shackleton Fund to paint for a newly-established collection.

Right: **Autumn Evening**
Gouache (53 x 76) INSC: lower right Ian Houston
Kind permission of the artist

Opposite: **Summer Clouds, Pakefield**
Gouache (31 x 41) INSC: lower left Ian Houston
Kind permission of the artist

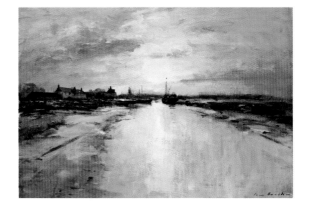

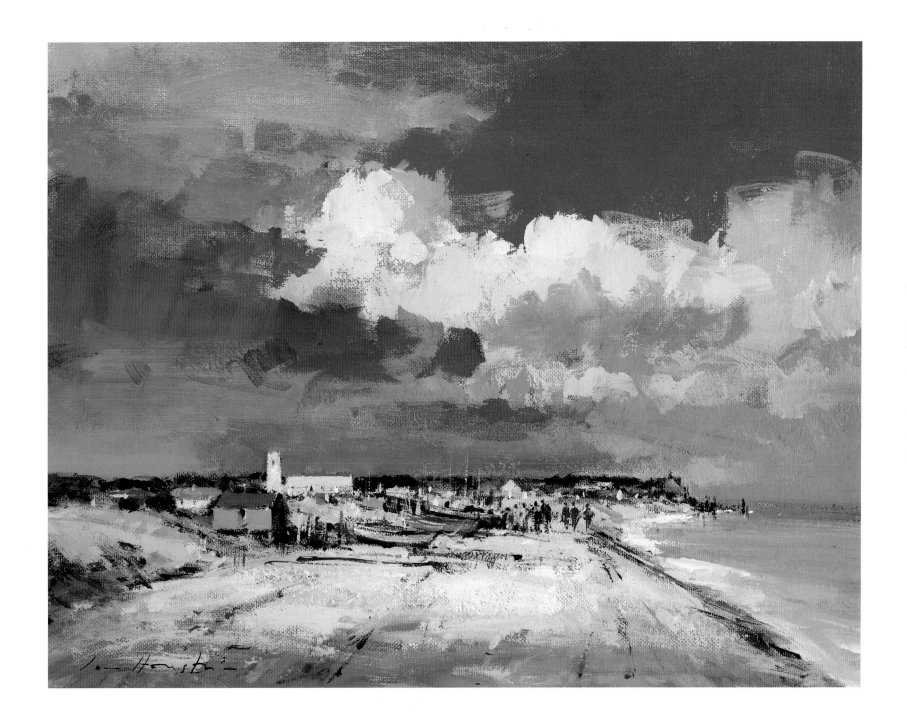

Wells-next-the-sea

2001 watercolour (33 x 50.8) INSC: lower right
David Talks. Permission of the artist

David Hallowell Talks b.1937

Began life in Wimbledon. He was educated at Mercers School, London, and Oxford University. He served as a Russian interpreter in the Royal Navy 1956–58 and RN Reserve until 1986. A self taught artist he began painting in watercolours while teaching modern languages at Gresham's School, Holt, Norfolk, 1963–70, and then at Rugby School 1970–88. In 1988 he turned to painting professionally. He has painted widely, in France, Italy, North Africa, and the Far East. Past President of the Rugby and

District Art Society and former Chairman of the NNAC. He lives in Norwich and owns a remote marshman's cottage on Breydon Water, Norfolk. Since 1988 he has exhibited regularly with the NNAC. He has also exhibited with the Royal Institute of Painters in Watercolour in London, the Royal Society of Marine Artists at the Mall Galleries, and the East Anglian Group of Marine Artists of which he is a Committee member. Also exhibited in galleries in London, Dorset, Hampshire, Warwickshire, Suffolk and Norfolk. Since 1988 he has had an annual exhibition in Rouen. He also arranges exhibitions for East Anglian artists in Rouen and for Rouen artists in Norwich as part of the Norwich-Rouen twinning link. He received a Gold Medal for his services to French Culture in 2001.

Lance Antony Beeke b.1939

Born in Maidstone, he was educated at Coringe Memorial Boarding School, Kent. He attended Gravesend College of Art and Maidstone College 1959 to 1963 attaining a BA in Fine Art, Graphic Art and Silversmithing. RAF 1964 to 1966. Lance descibes himself as a post-impressionist 'plein air'

Cherry Blossom
Oil on board (51 x 61) INSC: lower right L A Beeke
Private collection, Judy Hines Art Gallery, Fish Hill, Holt

painter influenced by Corot, Vuillard, Bonnard, and some modern English painters. He presently lives in Cromer, therefore the sea, towering cliffs and fishing boats are prevalent among a wealth of inspiring subjects. He also finds the island of Gozo with its rugged rocky landscape and sundrenched bleached buildings a contrasting atmosphere. Exhibitions: Ministry of Culture Gozo 1991; Artist in Residence Victoria Citadel Gozo, 1992; 1995 RA Summer Exhibition; 1997 Laing Art Competition Winner, Mall Galleries, London.

Peter Baldwin b.1941

Born in Aldeburgh, Suffolk. Studied at the Norwich School of Art 1958–62. Taught and practised in Canada 1963–65. He taught at Norwich School of Art, 1965–72 and in Norfolk County Council Adult Education Centres, 1972–91. He is also a lecturer in Art History for the University of East

Kentbrook
(Peter Baldwin)
1998 oil on board (61 x 61) INSC: lower right.
Collection of Richard Dilwyn-Jones

Anglia Extramural Board and the Workers Education Association. He fell out with the NNAC over the selection of 'modern' work but continued to exhibit with the Twenty Group. He describes himself as an 'old fashioned modernist', developing a clear and consistent language of form with a content that allows for cryptic symbolism and implied narrative. His influences are two great figurative artists, Balthus and Michael Andrews RA who was his tutor at Norwich School of Art (also a former member of NNAC). He has been involved in group exhibitions in Canada, USA, London and Rouen and with the Norwich Twenty Group since 1962. Eastern Open 1999, 2000, 2001, 2002. 'On The Edge' North Norfolk Exhibition Project, Salthouse Church, 2002. The East Anglian Group of Marine Artists Exhibition, Kings Lynn, 2002. Work in Public Collections; Norwich Castle Museum, Norfolk County Council, North Norfolk District Council.

Beeston Hill
(Peter Baldwin)
Oil on board (84 x 69) INSC: lower right. By kind permission of North Norfolk District Council

Harry McArdle b.1941

Norfolk born, he attended the Sir John Leman Grammar, Beccles, until 1958, followed by two years at Lowestoft College of Art, two years at Loughborough College of Art and finally in 1962 to 1963 University of London Institute of Education. He worked from 1963 until 2002 as a lecturer at Chesterfield College. He began his working life as a textile designer but started painting and etching as a hobby in the mid-1970s. His interest in watercolour was inspired by John S. Cotman and J.M.W. Turner. His main subject interests are Norfolk land and seascapes, Derbyshire landscape and still life. His paintings fall into two media, pure watercolour and mixed water-based media. Exhibitions: Sheffield National Open 1980/81; RI, Mall Galleries, 1983 and 1984; Sheffield Open, Mappin Art Gallery, 1985; British International Miniature Print Biennale, Bristol Museum, 1989; Eastern Open, King's Lynn, 1991 onwards; Derby Museum & Art Gallery Open, 1991, 1996, 1998, 2nd, 3rd, and Joint 1st prizes; RA Summer Exhibition, 1992; RWS, Daler Rowney Award, 1992 and 1996; Singer and Friedlander/Sunday Times Competition, 3 times 1995–1998; and others.

Salt Marsh, North Norfolk
Mixed media (66 x 92) INSC: lower left Harry McArdle. Kind permission of the artist

Above left: **Late Summer, Norfolk**
Watercolour (92 x 66) INSC: lower right Harry
McArdle. Kind permission of the artist

Above: **Evening, Oil Seed Rape**
Mixed media (92 x 66) INSC: lower right Harry
McArdle. Kind permission of the artist

Colin Bristow 1943–2002

Born in Eastbourne, Sussex. Studied commercial art at Eastbourne School of Art. Worked as a commercial artist for a time, but gave this up to concentrate on painting. Colin made little attempt to market his work, working quietly in his Watton studio. He was fascinated by the challenge of

View of a Room
(Colin Bristow)
Oil on canvas (71 x 102) Private Collection

portraying what he called the 'edge of reality', a romantic surrealism. The picture, 'View of a Room' is an exquisite study of his daughter Emma playing the piano in an interior, seen from the outside, with reflections from the patio on the window glass. He was also a wood sculptor and carver. In 1980 Colin moved to Norfolk, where he has occasionally exhibited his work. He died in Watton, aged 59, much mourned by his wife Miffy and family.

Christopher Penny 1947–1996

Born at Blandford Forum, Dorset. Studied at Bournemouth College of Art and Design 1964–8. Visiting lecturer at Bournemouth College of Art, Chelsea College of Art and Harrow College of Art 1968–70. Master Printer at Studio Prints Atelier, London, 1968–75, Head of Printmaking at Byam Shaw School of Art, London, 1970–77 and in 1982 John Brinkley Fellow at Norwich School of Art, where he taught etching. He had one-man shows in London and East Anglia, as well as America and Japan, and his prints were included in several public and private collections. Among the leading fine art publishers that have published his prints are Christie's Contemporary Art, the Royal Academy, Grafffiti, the National Trust and American Express. A skilled etcher of precisely detailed landscapes, he described himself as 'a tonal draughtsman rather than a strong colourist'.

Ferny Wood
1984 etching and aquatint (plate 36.5 x 30) INSC: lower margin Artist's Proof/Ferny Wood/Christopher Penny. Private Collection

Dianne Branscombe b.1949

She attended University of London, Goldsmith's College 1969–72, and trained as a teacher of art and ceramics. Dianne paints mainly still life in the Dutch style, slowly building up with successive varnishes a depth and brilliance to be truly representational. Among other exhibitions she has exhibited as follows: 1983–92, solo in Norwich; 1986–92, Annual Exhibition of the Royal Miniature Society of Painters, Sculptors and Gravers; 1992–2002, Annual Exhibition of the Society of Women Artists; 1993–2002,

The Nut Crackers
(Dianne Branscombe)
Oil on canvas (25 x 30) By kind permission of the artist. Courtesy of Llewellyn Alexander Ltd, London

Exhibits at 'A Million Brushstrokes' at Llewellyn Alexander (London); Summer Exhibition at the Royal Academy, 1993, 2000; 'Women of the New Millennium 2000', Linda Blackstone Gallery, 2000; Assoc. Member of the Royal Miniature Society of Painters, Sculptors and Gravers (ARMS), 1993; Member of the Society of Women Artists (SWA), 1994; Full Member Royal Miniature Society of Painters, Sculptors and Gravers, 1996; The Masters Award for the Best Set of Larger Paintings 'A Million Brushstrokes' exhibition, Llewellyn Alexander, 1999; 'The Best Set of Miniatures' Award at the Annual Exhibition, The Royal Miniature Society of Painters, Sculptors and Gravers, 2000; Finalist in *International Artist Magazine* 'Still Life Exhibition', 2001.

The Five Senses
(Dianne Branscombe)
Oil on panel (44 x 59) By kind permission of the artist. Courtesy of Llewellyn Alexander Ltd, London

Nick Deans 1950–1991

Born in Kent, the second son of a New Zealand landscape painter, he was brought up and educated in New Zealand. In 1971 he returned to the UK via SE Asia and South Africa. 1972–3 attended Ravensbourne School of Art, London. 1973–77 Goldsmith's School of Art, London. 1974 married Victoria Rhodes. Underwent his first kidney transplant at Dulwich Hospital. 1978–79 teaching and travelling in New Zealand. A sculpter in stone and bronze, he produced both figurative and more abstract works. In 1991 he received a second kidney transplant but died. Selected one man exhibitions: 1978 New Zealand House, London; 1981 Fermoy Gallery, Norfolk; 1986 Barbican Arts Centre, London; 1988, 1989 Galeria Schubert, Milan, Italy; 1990 Smith Jariwala Gallery, London. Work in collections in Spain, Portugal, USA, Saudi Arabia, New Zealand, Germany, Italy and England.

Girl Golfer
Marble (2m x 1m) Permission of Mrs N. Deans

Nude Resting
(Gareth Hawker)
Oil

Gareth Hawker b.1950

He studied art at the Byam Shaw School (1968–71) and at the Royal Academy Schools (1971–74). He gained the Robin Guthrie Memorial Award for portrait drawing, the David Murray Landscape Studentship, and the highest award for drawing (silver medal). He moved to Norwich in 1974 where he was given the Greenshields award which enabled him to paint for two years. Initially a still life painter, he gradually realised his ambition to make his living entirely from portraiture. He is married with two daughters. Commissions: Lady Mackay of Clashfern; Sir Greville Spratt GBE TD JP DL, Lord Mayor of London 1987–88; Sir Alexander (Mike) Graham GBE, Lord Mayor of London 1990–91; Sir Oliver Chesterton, First Master the Worshipful Company of Chartered Surveyors; Major-General David Houston; Sir Geoffrey Cass MA CIMgt; Earl Cadogan DL; Sir Martin Laing CBE; Lord Catto; Hon. Pamela F Gordon JP MP, Premier of Bermuda 1997–98; and many more.

Martin Laurance b.1952

Martin was born in the Middle East. He was educated at Ipswich School of Art in Portrait and Sculpture, Norwich School of Art – Life Drawing and the University of East Anglia BA Ed., Art and Design. He lives in Norwich with his wife and children and is a full-time artist. He began his artistic life as an engraver and graphic designer, then devoted his time to life drawing exhibiting few of his works from this period while running his own frame shop. In the mid-nineties he turned to topographical subjects, particularly seascapes. His paintings are full of colour, whether oil, watercolour, acrylic or mixed media. He likes to walk an area, sketch and take notes and then in his studio reconstruct the landscape, often using multi-layered techniques including collage. The form is loose and liquid and he concentrates on depicting mood and atmosphere with intense colours that give his work a Mediterranean feel. He often returns to a theme as he finds new ways to redefine his experiences. He has had solo exhibitions in The Music House Gallery, Snape Maltings, Suffolk; John Russell Gallery, Ipswich. Selected Group Exhibitions: 1992–9 Royal Institute of Painters in Watercolour, Mall Galleries, London; Castle Museum, Norwich; 'Recent Acquisitions' Deloitte & Touche, Zurich. The

Riverside Gallery, Snape Maltings, Suffolk. John Russell Gallery, Ipswich. 2001: 'British Contemporary Art', Deloitte & Touche, Zurich. 2002: Last Gallery, Zurich. 'Eastern Open' 1998, 1999, 2001 Fermoy Gallery, King's Lynn Norfolk. Paintings in private collections in Europe, Japan, USA, and Canada and the Sainsbury Centre Print Loan collection, UEA.

Above left: **Winter Moon, Port Isaac**
(Martin Laurance)
Oil on canvas (61 x 76) By kind permission of the artist

Above: **Ionian Landscape**
(Martin Laurance)
Acrylic and collage on canvas (102 x 76) By kind permission of the artist

Liverpool Street Station, Day
(Graham Rider)
Oil (60 x 40)

Graham Rider b.1956

Graham was educated at Southend School of Art 1976–77 and Norwich School of Art 1977–80 where he obtained a BA Hons Fine Art, Painting. In 1984 he became a teacher in the Norfolk Adult Education Service in Norwich where he lives, and has regularly exhibited with the NNAC. His style has ranged from painstaking reproductions as in such compositions as Liverpool Street Station, commissioned for Railtrack, to a fascination with the beach and the patterns of marram grass. Many of his later works have a looser style. He has exhibited at Venice in Peril, WH Patterson Fine Art London, 1997 to 2002. Other mixed exhibitions: Stowells Trophy, Royal Academy London, 1978; Art 90, Islington, 1990: Drawings for All, Gainsborough's House, 1990; Spectator Art Prize, London and Edinburgh, 1990; ROI, Mall Galleries, 1990; British Painters 90, Westminster Galleries, 1990; Summer Exhibition, Heffers Gallery, Cambridge, 1992; Summer Exhibition, Waterman Fine Art, London; Spectator Art Prize, London and Edinburgh 1993; Drawings for All, Gainsborough's House, 1994; Eastern Open, King's Lynn, 1994; Spectator Art Prize, London & Edinburgh, 1994; Eastern Open, King's Lynn, 1996; Laing Seascape and Landscape Competition, Mall Galleries, 2002. He has pictures in the following corporate collections: Suffolk Social Services, Ernst and Young, Railtrack, Guardian Royal Properties, Jarrold & Sons.

Barn Owl
1993 watercolour paper (76 x 66)
INSC: lower right Michelle Bennett Oates
Private Collection

Michelle Bennett Oates b.1958

Michelle studied under her father Bennett Oates (q.v.) and established herself as a wildlife artist. She was elected to the Society of Wildlife Artists in 1983. She has exhibited annually in the Society's exhibitions at the Mall Galleries, London. Much of her time is spent fulfilling private commissions for flower paint-ings, and portraits of dogs and horses. She has recently begun flower paintings in the Italian style, setting flower pieces in a classical Italianate setting. Michelle now lives in Devon on the edge of Dartmoor.

Michael Checketts b.1960

He was born in Harpenden, Hertfordshire. Art education at Norwich School of Art 1981–84, Royal Academy Schools 1984–87. After his training he was soon successful. 1990 Third Prizewinner the Spectator Art Competition; 1990 BP Portrait Award, National Portrait Gallery. 1994 First Prizewinner the Spectator Art Competition. 1997 First Prizewinner Eastern Open, Kings Lynn. 1998 BP Portrait Award, National Portrait Gallery. 2002 Second Prizewinner Eastern Open, Kings Lynn. 1996 solo exhibition Battersea Library London. His quirky self portraits of his life and stylised land and seascapes have a style and attraction all of their own. Bibliography: 1990 *The Spectator*, 'Art Prize Review', Giles Auty 7.3.90. 1994 *The Spectator* Magazine, 'Oiling your way to the top', Giles Auty 7.11.98. 1998 *Eastern Evening News*, 'London Diary', Ian Collins 26.6.98; *Financial Times*, 'Changing face of competition', William Packer 7.7.98. *Artists and Illustrators'*, 'Modern Madonnas', Susan Wilson 12.98. Collections: Manchester City Art Gallery, University of East Anglia Library, Adam & Company (Edinburgh).

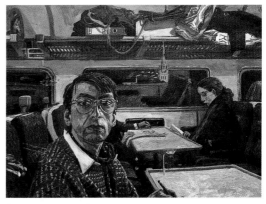

The London Train
(Michael Checketts)
Oil on canvas (82 x 60)

Gale at Gorleston
(Michael Checketts)
Oil on canvas (90 x 120)

Above: **St Felix**
(Mark Goldsworthy)
Oak, height 3.7m

Right: **Still Water**
(Mark Goldsworthy)
Oil on canvas (50 x 75)

Mark Goldsworthy b.1962

Educated at Wymondham College, Norfolk, 1974–81, then 1981–82 a foundation course at Great Yarmouth College of Art and Design. That same year he worked as a deckhand aboard a 130 feet sailing barque. 1983–86 BA (Hons) Fine Art, Manchester Polytechnic followed by a three-month tour of European Galleries. The following years he spent as a painter in Norwich and gave a weekly life class in his studio. He designed the stage set for the Rolling Stones World Tour, 1994. He views life as 'a series of adventures into the unknown and derives great pleasure from his materials, oils, pastels, wood and silver', as well as from his wife and daughters. Exhibitions: Eastern Open 1988; Pastel Society, Mall Galleries 1990; Laing Art Competition, Ipswich, 1991; Bankside Open Print Competition 1991; One man Show, L'Orangerie, Valenciennes, France; Wild Contemporary Art, Mall Galleries 1991, 1994; Laing Competition, Bury St Edmunds & Mall Galleries 1993; New York Art Fair, USA, 1999. Collections: North Norfolk DC; North Walsham TC; Norwich City Council; Waveney DC; South Norfolk DC; Sandringham Estate.

Rules of the Norwich Art Circle 1885

I That the Society be called 'THE NORWICH ART CIRCLE'.

II That the objects of the Norwich Art Circle be to bring together Artists, Amateurs, and others interested in Art, to provide periodicals, books, and catalogues, having reference to Art, to arrange for the Exhibition in the Society's Room, or elsewhere, of Pictures, Drawings, and other works of Art, to render the Society a centre where conversazioni may be held of an Art character, and generally to promote a knowledge and love of the Fine Arts.

III That the Society consist of a President, Vice-President, Treasurer, and Secretary, and a Council and Members.

IV That the President, Vice-President, Treasurer, and Secretary, be elected at the Annual Meeting of the Council to be held in January, and be eligible for re-election.

V That the Council consist of the original promoters, with power to add to their number from the Members of the Society by ballot, in the same manner as is prescribed for the election of Members of the Society.

VI That the conduct of the Society rest with the Council only.

VII That a Monthly Meeting of the Council be held in the Society's Room, five to form a quorum, who in the absence of the President or Vice-President shall have power to appoint a Chairman. At all Meetings the Chairman to have a casting vote.

VIII That any person desirous to become a Member of the Society be proposed and seconded at a Council Meeting by two Members of the Council, and be balloted for at the following monthly meeting, a majority of four-fifths of the Members of the Council voting being required to elect.

IX That there be at least one Annual Exhibition of Works by the Members of the Society.

X That each Member of the Council shall be entitled to exhibit a limited number of his works at the Exhibition of the Society.

XI That Members have all the privileges of the Society, but that any of their works sent for exhibition be submitted to the approval of the Council.

XII That every Member of the Society pay the Annual Subscription of one guinea to be due in advance on the Ist of January in each year.

XIII That the Secretary shall collect and pay all moneys to the Treasurer, who shall deposit the same on account of the Society in such Bank as the Council shall appoint, and that any disbursement the Treasurer may be called upon to make on account of the Society be previously sanctioned by the Council, and the account signed by the Chairman.

XIV That a General Meeting be held during the month of January in each year, when the Statement of Accounts and Reports shall be read.

XV That in case of loss resulting from the working of the Society, such loss be borne in equal shares by the Members of the Council.

XVI That should any Member of the Council withdraw from the Society, he forfeit all claim to a share of the funds or other property of the Society, and be held responsible for his proportion of the Society's liabilities arising from engagements made previous to his notice to withdraw.

XVII That the Council have the power of publishing such papers, etchings, engravings, and other illustrations, being the work of Members of the Society at the Society's expense, as may be deemed worthy of publication. That each Member be entitled to a copy of such publication either gratis, or at such price as the funds of the Society will admit from the time of his election; and to such further copies and previous publications (if any there be in hand) at a price to be fixed by the Council.

XVIII That the Council have power to open the Society's Room on any day in the week.

XIX That no new rule or alteration of a rule shall ever be made at any meeting of the Council without the sanction of a majority of two-thirds of the Members present; nor unless the proposed new rule or alteration has been posted on the Notice Board of the Society's Room fourteen days previous to the day of meeting.

Exhibiting Members

Exhibiting Members 1885–2003

This list of exhibitors has been compiled from the exhibition catalogues. No catalogues were issued during the years 1939–45 although exhibitions were held.

Names: Women members who later exhibited under a different, married name appear under the name with which they first exhibited, but are cross-referenced under their married name.

Addresses: Where members frequently changed addresses, the long-standing ones only are given.

Dates: The dates given are the first and last years in which members exhibited, although they did not necessarily exhibit annually, nor does the last year necessarily mean that artists ceased being members from that date.

c Council members

c Non-exhibiting Council members

w Also a member of the Woodpecker Art Club. No complete set of catalogues exists for the Woodpecker Art Club so that it has not been possible to include all members.

w Members of the Woodpecker Art Club who did not exhibit with the Art Circle. Because of the lack of records it has not been possible to establish whether or not they became members of the Art Circle at the time of the merger.

* Works exhibited posthumously.

Abel, Derek Deeping St James	1983–4
Adcock, Alwin Ipswich	1952–3
Adcock, Ernest D. (w) Norwich	1899–1928
Ahn, Frederick M. Bury St Edmunds	1979
Aitchison, Bruce Bury St Edmunds	1977
Aitken, Miss W. Rose (w) Felixstowe; Barnet	1929–32
Alderton, S.C. Norwich	1929–30
Alderton, Mrs Winifred Lowestoft	1961–6
Aldis, Miss E. Louise (w) Norwich	1893–1910
Aldiss, Miss Helen	1927
Alexander, Jean Thelveton	1977–92

Allen, Charles Thorpe	1952–63
Allen, Doreen (Mrs R. Crampton) (c) Great Massingham	1971–88
Allen, Frank Humphrey Swanton Abbott	1951–2
Allen, James J. Norwich	1975–87
Allen, James Norwich	1990
Allen, K.E.W. Blakeney; Norwich	1935–8
Almey, Mary (c) Norwich	1983–2003
Alston, Miss Charlotte M. (w) London	1912
Amherst, Hon. Sybil (w) London	1912–26
Anderson, Ralph Glasgow	1957
Andrews, Michael J. Norwich	1948–50

Anthony, John V.C. Norwich	1948–50	Ballachey, Miss Mary E. (w) Norwich	1898–1900
Apthorpe, Henry Campion Cambridge	1898–1900	Banger, Mrs Joan R. (c) Norwich; Bramerton	1964–94
Apthorpe, Henry Guy Palgrave	1936–61 *	Banger, Raymond H. (c) Norwich; Bramerton	1970–2003
Archer, Miss Ada London	1891	Barber, Mrs Clarice Southwold	1961–4
Archer, John H. Norwich	1947	Bardswell, Mrs N.D. Midhurst	1908–10
Arkwright, Miss Olive (w) Sheringham	1930	Barker, Edward (c) Norwich; Newton Flotman	1952–66
Armes, Thomas William Sheringham	1952–63 *	Barker, Herbert Norwich	1949–65
Armstrong, Revd Herbert B.J. Thorpe King's Lynn; Holt	1931–53	Barker, Mrs Ruth (c) Norwich; Newton Flotman	1949–59
Arnold, John Norwich	1953	Barkham, Miss Kathleen A.M. Hunstanton	1930–50
Arnold, Peter J. (c) Blundeston; Brundall; Surlingham	1951–80	Barklam, Harold Lowestoft	1947–50
Ashford, Mrs Ethel Mary Geldeston	1946–9	Barnard, Miss G.V. (ex-officio) (c) Norwich Castle Museum	1947–51
Ashford, Mrs O.M. (c) Aldeby	1934–46	Barnard, Kathleen (c) Norwich	1977–8
August, Lillias Bury St Edmunds	1988–90	Barnard, Mrs Mary A.I. (c) Norwich	1957–98
		Barratt, Legh Sheringham	1938–48
Back, Robert T. Oulton Broad	1946–53	Barrett, V. Willoughby (w)	1910
Back, W. Edward (w) Oulton Broad	1907–8	Bartle, Mrs K. Reepham	1936–7
Bacon, Barry C. Fakenham	1977	Barton, Miss Mary London	1898
Bagge Scott, Robert (cw) Norwich	1886–1924	Barwell, Miss Edith L. London	1895–1901
Bagge Scott, Miss (c)	1931–6	Barwell, Frederick B. Sheringham	1899–1910
Baggott, Miss Dora Norwich	1913–15	Barwell, Henry George (c) Norwich	1885–99 *
Bailey, Angela Lowestoft	1990–2003	Barwell, Miss Louisa Mary Norwich	1898–1910
Bailey, Mrs Arthur Wramplingham	1905–24	Barwell, Stanley, W. Sheringham; West Runton	1904–14
Bainbridge, Mrs Mildred E. Coltishall; Buxton	1931–8	Barwick, Paul (c) Edingley, Newark	1978–92
Baker, Miss P.J. Norwich	1946	Bassett, Mrs Daphne Norwich	1970–2
Baldrey, Samuel H. Norwich	1887–9	Batchelder, Stephen John Great Yarmouth	1927–9
Baldry, Nellie (w)	1893	Batchelor, A. (w)	1912
Baldwin, Peter (c) Sheringham	1988–92	Bath, Miss Elizabeth J. (w) King's Lynn; Heacham	1908–30
Balkwill, Elizabeth Hemblington	1990	Batley, Walter D. Ipswich	1932
Ball, Frank J. Norwich	1914	Baxter, David Norwich	1986–2003
Ball, Timothy Peter Norwich	1971–2	Bayfield, Miss F. Jane (cw) Norwich	1886–1928 *
Ball, Wilfred W. London	1887–94	Bayliss, B.G. Norwich	1947

Bealey, Betty Ditchingham	1989–99	Bolton, Graham Herbert Dersingham	1966–70
Beare, Peter Lowestoft	1962–5	Bolton, Miss Nell King's Lynn	1950–65
Beattie, Miss M. Norwich	1928–46	Boorman, Charles Thorpe	1964–8
Beckett, Alan Gt Yarmouth	1990	Boswell, Miss Faith K. (Mrs Sage) Norwich; Surrey	1909–34
Beckett, Grace Norwich	1987–89	Boswell, Patrick John Norwich	1975–9
Bee, Mrs Margaret (c) Norwich	1974–94	Boughey, Mrs E. Fletcher St Peter in Thanet	1911
Beeke,Lance Norwich	1989–91	Bourne, Mrs Alice Ella Southwold	1957–61
Bell, Graham Norwich	1987	Bowen, Brian E. Thorpe	1967–70
Bender, Miss Anne North Walsham	1953–5	Bower, Mrs Renee Wroxham	1967
Benedicta, Sister Dereham	1961–88	Bowman, Janet Barnham Broom	1989
Bent, Charles Sydney South Wootton	1951	Bowman, Miss Veronica Aylsham	1955
Bentall, Anthony Pearton (c) Norwich	1947–83	Brandon-Hood, June (c) Norwich	1973–99
Berry, Herbert Ronald Alfred Norwich	1959	Branscombe, Dianne Surlingham	1984–90
Besley, F.W. Halesworth	1938–46	Brasnett, Joan Thorpe, Norwich	1972–85
Beverley, Arnold M. Norwich; Halesworth	1946–53	Breese, Thomas S. Norwich	1885–9
Beverley, Frank Norwich	1988–89	Brennen, Eileen Watton	1985–88
Beverley, Miss Merrie Norwich	1902–5	Brennand, Janet (Mrs Marsh) East Winch	1927–9
Biggs, E. Arnold (w)	1913	Breton, Miss E.M. Norwich	1932–46
Biggs, John R. Norwich	1949–51	Bridges, Miss Clara E. Kettering	1908–11
Birkbeck, Mrs Stoke Holy Cross	1896	Bristow, Colin Great Cressingham; Watton	1982–3
Birkbeck, Geoffrey (cw) Thorpe; Postwick; London; Stoke Holy Cross	1895–1938	Britton, Mrs June Mundesley	1965–75
Birkett, Miss Ann Marie (c) Norwich	1967–80	Brooke, F. William Saxmundham	1889–95
Black, Sheila North Walsham	1992	Brookes, Miss Daisy M. Norwich	1949–58
Blackden, M.W. (w) Oulton Broad	1898	Brooks, W.T. Percy (w) Norwich	1911–20
Blake, Aubrey A. (cw) Norwich; Bramerton	1893–1938	Broom, Miss Marion (w) Hemsby	1901
Blake, Miss M.M. (Mrs G.T. Carre) (w) Norwich	1886–1902	Brown, Mrs A.A. Norwich	1933–8
Blanchard, Pat (c) Norwich	1996–2002	Brown, Miss Alice H. Norwich	1889
Blofeld, Miss L.C. Hoveton; Chipping Norton; Yateley	1899–1934	Brown, Arnesby (c) Haddiscoe	1916–37
Boit, Miss Julia O. Norwich; Coltishall	1927–8	Brown, Mrs Arnesby (Mia Edwards) Haddiscoe	1916–18
Bolingbroke, Leonard G. (c) Norwich	1895–1927	Brown, Mrs Audrey J. Hellesdon	1965
Bolingbroke, Miss Minna (Mrs C. J. Watson) Norwich; London	1885–99	Brown, Edith Norwich	1988

Brown, Mrs F.M. Garrett Ipswich	1932	Burton, Peter Edward Gooderstone	1956–60
Brown, Hugh Boycott Bushey; Blakeney	1937–53	Bussey, Michael Algar Thorpe	1958–60
Brown, James E.H. Brundall; Blofield; Norwich	1935–47	Butcher, Francis William Forncett St Peter	1951
Brown, J. Leslie Norwich	1936–38	Butler, Miss J. Burnham Overy Staithe	1936
Brown, Winnie Norwich	1989–90	Buxton, Miss Carolyn G. Catton; Whissonsett	1901–12
Brown, Leslie Norwich	1977–81	Buxton, Mrs Edward G. Thorpe; Catton	1897–1912
Browne, Henry E.J. Hethersett; London	1887–95	Buxton, Miss M. L. Bolwick	1909
Bruce, Mrs H.M. Belton	1937	Buxton, Miss Rosalind Fritton	1902–8
Buckingham, Ernest Hugh Norwich	1933–52	Buxton, Miss Theresa Buckhurst Hill	1900–6
Buckingham, Miss Ethel (Mrs Charles Havers) (w) Norwich	1891–1917	Buxton, Miss Winifred (Mrs Waterfield) (cw) Fritton; Attlebridge; Snape	1895–1953
Buckingham, F. Maidie (c) Norwich	1926–85	Bygrave, Colin Melton Constable	1996–99
Buckingham, G. Norwich	1935		
Buckingham, Geoffrey S. Cringleford; Norwich	1946–79	Caddick-Adams, Mrs Dorothy M. Blakeney	1954–9
Buckley, Miss A.C. Norwich	1934–38	Caddick-Adams, Thomas Geoffrey Blakeney	1954–5
Buckley, Miss H. Blanche London	1907–10	Caldwell, Elizabeth Belaugh	1984
Buckworth, Miss M.P. Crostwick	1899–1903	Calderon, Frank (w) Liphook	1904
Budd, Miss Rosa A.J. Great Yarmouth	1897–1901	Camp, Jeffery Bruce Lowestoft	1946–59
Bulmer, Revd E. Norwich	1886–7	Campbell, Hon. Mrs Thorpe; Weasenham; Keith	1897–99
Bunnewell, Leon Norwich	2001	Campion, Miss Cherida Old Catton	1956–9
Burdick, Graham J. Spixworth	1963	Canham, Alan J. Norwich	1969–70
Burgess, Miss (c)	1928–31	Canham, Ray Filby	1988
Burgess, Harrold (w) London	1904	Cannell, J. S. Norwich; St Albans	1935–46
Burgess, Miss Mary Lizzie (w) Norwich	1901–13	Canter, Mrs Doris A. Norwich	1937–50
Burgess, Trevor Norwich	1987	Cantrill, Mrs I. Walcott	1935
Burnham, Stephen Hellesdon	1947–58	Carey, Mrs Leicester Lamas	1936–8
Burrell, Miss Elsie Thetford; London	1906–13	Carpenter, Mrs Winifred Wiveton	1952
Burrows, Geoffrey N. (c) Spixworth	1975–2003	Carr, David Starston	1946–7
Bushell, Raymond (c) Norwich	1996	Carr, Mrs L.C. Overstrand	1899–1903
Burton, Mrs Agnes Beverley Abergavenny	1948–58	Carr, Miss Mary Hedenham	1913–35
Burton, Mrs Beryl Hope (w) Litcham; Costessey	1908–65	Carré, Mrs (w) Sprowston	1901
Burton, John E. (w) Norwich	1902	Carrick, Miss Elsie (c) Norwich	1947–78

Carruthers, Mrs Gabriel Joan Brooke; Salisbury	1957–61	Clarke, Miss Joan Eleanor Norwich	1953–5
Carruthers, Hon. Mrs Mary (c) Barmer; Burnham Overy Staithe	1931–56	Clarke, Miss Mia Welham Redenhall	1900–7
Carter, Leslie Norwich	2003	Clarke, R.R. (ex-officio) (c) Norwich Castle Museum	1952–62
Carver, Walter New Costessey	1985	Clarke, Sally Sprowston	1985–90
Cary, A.L.F. Weybread; South Walsham	1951–8	Clausen, George (w)	1904
Cato, T. B. London	1935	Clayton, Mrs Bunty Hunstanton	1965–6
Chambers, Frederick C. Thetford	1963	Clowes, Charles (c) Norwich	1885–1900 *
Chance, Ernest (w) Heigham	1923–7	Clutterbuck, Mrs Violet E. (cw) Northrepps; Marsham	1897–1938
Chandler, Isabel M. Gorleston	1946–50	Cockrill, Miss Mabel (w) Brundall	1901–4
Chaplin, Mrs Ethel Mary Norwich	1970–81	Cocks, Fred Dereham	1955–9
Chapman, Dorothy I. Pulham Market	1983	Codd, James Arthur Norwich	1949–57
Chapman, Mary Old Costessey	1980–96	Colby, Mary Chediston	1977
Chapman, Paul P. Brundall	1977	Cole, Miss Elsie Vera (w) Braintree; Norwich	1919–66
Charles, Frank Norwich	1978–2003	Cole, Miss Nellie E. Gorleston	1946–51
Charteris, Lady Louisa Hingham	1908–9	Colebrook, Nigel Lowestoft	1983–4
Chase, Miss L.M. Norwich; London	1933–8	Collard, J. Sea Palling	1935
Checketts, Michael Norwich	1995–99	Coller, Miss Beryl C.M. (w)	1927
Chenery, Stephen Frederick Shipdham	1952	Collin, Harold Edward Norwich	1936–73
Chettleburgh, Jane Norwich	1994	Colls, Marjory Eleanor West Runton	1977–8
Chipperfield, Edmund Walter Melton Constable	1959–73	Collyer, Miss Mildred H. (w) Wymondham; London	1910–11
Chipperfield, Eddie (c) Old Catton	1998–2000	Colman, Beryl Colney	1973–4
Churchill, Mrs Helga Pulham Market; Dereham	1954–85	Colman, David New Costessey	1975–83
Churchman, Miss Dorothy Adelaide Woodbridge	1949–51	Colman, Miss Penelope Anne Framingham Chase	1954–8
Churchyard, W.J. Norwich	1886–7	Coman, William J. Acle	1934–52
Cirel, Ferdinand L. Thorpe; Roath	1947–63	Combe, Elizabeth Blakeney	1950
Clark, Miss Deborah Norwich	1908–11	Comrie, Elizabeth Cringleford	1997–2001
Clark, George O. (c) Norwich	1886	Conder, Mrs Mary Weston Beccles	1971–91
Clark, Mrs Libuse Anna Brundall	1960–72	Conti, Mrs Ellen Homersfield; Cavendish	1949–60
Clark, Mrs P.N. Hickling	1921	Cook, Mrs Alice M. Spixworth	1949–59
Clarke, C.S.B. (w)	1895	Cook, Miss Anne S. (c) Norwich	1961–95
Clarke, George Swaffham	1974–6	Cook, Miss Ethel Margaret Shotesham St Mary	1951–3

Cook, Leonard J.C. Dunton	1962	Crisp, Mrs Winifred Horning	1969–70
Cook, Walter F. Spixworth	1949–52	Croll, Doris Old Costessey	1992–2003
Cooke, Connie Norwich	2001	Crook, Mrs Edward (w)	1908
Cooke, Miss D. Great Livermere	1933–5	Crookham, Miss Elfrida Beatrice Sheringham	1951
Cooke, May Norwich	2000–01	Cross, Miss Emeline (w)	1926–7
Cooper, Arthur Wellesley Harleston	1975–80	Cross, Miss May Postwick; Swainsthorpe	1904–11
Cooper, Miss Rosamund Le Hunte Sheringham; London	1947–53	Crosse, Joyce Norwich	1973–8
Cooper, Stanley Great Yarmouth	1947	Crotch, Leslie Norwich	1988
Cooper, W.P. Norwich	1919–36	Crotch, Mrs Phyllis R. Thorpe	1920
Copeman, Miss Irene Mary Norwich	1958–65	Culley, Miss Mabel (w) Norwich	1901–23
Copeman, Mrs Winifred Mary Sheringham	1967	Cundell, Mrs H.A. London	1934–5
Corbett, John Stuart Cardiff	1903–15	Curl, Ernest A. (cw) Thorpe; Sheringham	1923–50
Corke, Michael A. Norwich	1962	Curl, Mrs Ernest A. Thorpe	1933–8
Cornell, Diana Potter Heigham	1995–98	Curl, Henley Graham (c) Thorpe; Swainsthorpe; Wreningham	1935–87
Cossey, Mrs G.M. (w)	1910	Curnow, Elizabeth Norwich	1998–2003
Cotman, Frederic George (w) London	1887–93	Curry, Harry S. Ipswich	1932
Cotman, Henry W. (w) London	1904	Cursham, Miss Jane Blythburgh	1960
Cotton, Mrs Dorothy Linsday Botesdale	1957	Cusa, Dr Noel William Letheringsett	1968–71
Coulton, R.C. Pentney	1916	Cushing, J.H. Wymondham	1909–12
Court, William H. Gorleston	1978–82	Cutting, John Michael Cringleford	1958–59
Courteney, William Ronald (c) Norwich	1951–95		
Cowling, Marcus Dereham	1984–86	Dade, Olivia (c) Lingwood	2000–03
Cox, Mrs Florence (w)	1908–13	Dalton, Anthony (c) Eaton	1984–2003
Coxon-Ireland, Mrs Eileen Upper Stoke Holy Cross	1982–4	Danby, Mrs Edith Thorpe	1961
Cracknell, Richard Norwich	1953	Daniel, Capt. E.M. Wroxham	1938
Cracknell, Rupert Charles Bury St Edmunds	1960	Davenport, F.W. Leslie (c) Norwich	1946–73
Crampton, Ronald (c) Great Massingham	1971–85	Davenport, J.E.C. Norwich	1956
Crampton, Mrs R. – see Allen, Doreen		Davenport, Mrs Margaret Norwich	1946–8
Crane, Miss Winifred Drayton	1967–76	Davidson, Allan (w) Wroxham	1927–9
Craske, John East Dereham	1935–8	Davies, Arthur E. (cw) Norwich	1931–55
Crick, Montagu (w) Norwich	1899–1904	Davies, Mrs Mary Frances South Wootton; King's Lynn	1964–71

Davies, W. H. Castleford	1949	Downs, John S. Brundall	1974–9
Dawber, E. Guy Moreton-in-Marsh	1888–90	Dowson, Russell Windsor	1891–1913
Dawnay, Hon. Miss Ruth Hillington	1936	Draper, Mrs Joan Hoveton St John	1967
Deans, Nick Aldborough	1990	Drewitt, Geoffrey Crellin Norwich	1949–56
Dennes, Noel F.B. (c) Mattishall; Norwich, Costessey; Brundall	1933–82	Driver, Grace Edith Norwich	1979–81
Denny, Alexander (w) Norwich	1901	Ducker, Peter Wymondham	1966–7
De Poix, Edmond T. (w) Bungay	1905–16	Dudley, John V. (w) Heigham	1912–26
De Poix, Hugh Bungay; Ditchingham	1906–53	Dunbar, Miss Mabel Norwich	1957–65
De Soet, Ardoldus Bury St Edmunds	1979–80	Duncan, Mrs Rosalind Norwich	1970–87
Dexter, Walter (w) King's Lynn; East Winch	1902–55	Dunne, Donal	1973
Dicker, Mrs Margaret K. Acle	1949–57	Durrant, Miss Betty Stoke Holy Cross	1936–7
Dickson, Miss Delphine Mary (c) Norwich	1936–2003	Durrant, Patrick Horsham St Faiths	1987
Dickson, Mrs Nell G. (c) Norwich	1920–66 *	Durrant, Rosemary Norwich	1990
Dimascio, Anna Norwich	1988	Dusan, Mrs Veronica Aylsham	1957–64
Dimmock, Miss Wynne E. Cantley	1946–61 *	Dye, Ernest Sawford (w) Norwich	1893–1903
Dix, Eric J. Norwich, Baylham	1947–97		
Dixon, Eileen M. Norwich	1981	East, Alfred (w)	1904
Dixon, Margaret Norwich	1997	Eastick, Marion Old Catton	2001
Dixon, Mrs Winifred Swaffham	1969–70	Eaton, Miss Ellen M.M. (w) Sturry	1922–47
Dodd, James Stewart Holt	1952–61	Eckford, Alan Diss	1986–88
Dodman, Archibald H. Norwich	1927–31	Edgell, Anne Blofield Heath	2001–3
Dodson, J. Gordon (cw) Norwich; Cringleford	1919–33	Edwards, Mrs Joyce Francis Huntingdon	1966–72
Donaldson, Miss Catherine (w) London; East Runton	1923–6	Edwards, Miss Winifred Swaffham	1953–4
Douglas, Miss Penelope Barnham Broom	1967	Effemy, Doreen East Carleton	1988–2003
Douglas, S.J. Netherstead	1946	Eglen, Geoffrey H. Dereham	1950–1
Douglas-Willan, Miss Ethel Lamberhurst	1900–1	Ellenger, Revd Edward Norwich	1959
Dowling, Phyllis Costessey	1987	Elliot, Edward (w) Hethersett; Acle	1885–1910
Downes, H.R. (c)	1895–6	Ellis, Mrs Mary Norwich	1961–2
Downes, Miss V. (w) London	1896–8	Elwes, Miss Violet London; Grimston	1906–13
Downing, Mrs Marianne (c) Coltishall	1973–2003	Elwin, Mrs Fountain Booton	1926–37
Downs, Miss Helen M. Saham Toney	1932–5	Emms, H.C.H. Norwich	1920–22

English, Mrs Irving North Runcton	1936	Fitt, Cyril H.C. (w) Norwich	1927
English, Mrs Monica Gayton	1968	Fitt, G.	1889
Evans, Audrey Norwich	1999–2003	Fitt, Mrs Gertrude C. (cw) Norwich	1909–38
Evans, Mrs Violet Muir (w) Lowestoft	1921–7	Fitton, Tom Dereham	1956–7
Evans, Mrs Winifred Wroxham	1968	Fitzer, Lilly	1972
Everitt, Michael Boswell (c) Norwich	1964–2003	Fitzsimmons-Hall, Mrs Margaret P. (c) Norwich	1946–51
		Fletcher, Lady Helen Saxlingham; Hingham	1935–68
Fagg, Mrs Gloria Strumpshaw	1960–2001	Fletcher, Miss Hilda M. Marlingford	1907
Faircloth, Ernest W. (w) London	1922–38	Flint, Savile (w) Norwich	1901–3
Fairhurst, Joseph Norwich	1949–51	Flood, Mrs Mary Norwich	1962–73
Fairley, Mrs Evaline M. Sporle; Matlaske; Aylmerton	1957–79	Folkes, Lorna Reymerston	1998
Falcon, Miss Anne Burlingham	1946–8	Ford, William Henry New Costessey	1957–8
Fann, Miss Mildred C. Bunwell	1968–71	Forrest, Mrs Shotesham	1924
Fanning, Miss Dorothy Norwich	1907–15	Forster, Mrs Muriel A. Kessingland	1910–20
Farquhar, Miss Louie (w) Norwich	1920–29	Foster, John P. Hemingford Grey	1946–8
Farrer, Miss Fanny (w)	1896	Foster, Richard	1973
Farrer, John Alfred Norwich	1954–5	Fowell-Holman, Mrs Florence Norwich	1963–7
Faulkner, Mrs Mildred (c) Wroxham; Norwich	1957–80	Fowle, Mrs Catherine South Walsham	1964–9
Feast, Mrs R.E.C. Norwich; Thetford	1936–8	Fowler, Miss Alice L. Brimpton	1912
Ferrey, Wendy Surlingham	2001–03	Foxwell, Miss Mabel (w) Norwich	1901–20
Feilden, Miss Constance Mary Beachamwell	1899–1907	Francis, Mrs Iris May Vyvyan (c) Cringleford; Thorpe	1946–2003
Fell, Joseph I. Norwich	1976–8	Franks, Raynald Caister St Edmund; Colney	1951–64
Fiddian, Mrs Valerie Sprowston	1951–2	Freeborn, Archibald William Little Melton; Panxworth	1966–72
Filbee, Mrs Nancie Acle	1953–8	Freeman, David Charles Wymondham	1961
Filippi, Miss Juanita P. Norwich	1919–20	Freeman, Miss Lilian H. (w) Norwich	1893–8
Finch, Miss Lucy Willis (w) Norwich	1893–1914	Freeman, Miss Lucy J. (w) Norwich	1898
Fisher, Mrs London	1922	French, Gloria A. Eye; Loddon	1983–2001
Fisher, G.F. Fleggburgh	1908–13	Frere, Miss Amy Hanbury (w) Norwich	1902–58
Fisher, Miss Janet Angela Hellesdon	1953–4	Frere, Miss Margaret Hanbury (w) Norwich	1928–56 *
Fisher, Rowland (c) Gorleston	1935–56	Freschini, Stanley C. (c) Norwich	1970–94
Fitt, Mrs Beatrice Pakefield	1957	Fry, Miss Bessie (w)	1908

Fry, Mrs Rosa Mundesley	1971	Gill, Miss Muriel Ethel Norwich; Ketteringham	1947–83
Fugl, Miss Bertha (w) Norwich	1928	Gillan, Mrs I.J. Sheringham	1933–8
		Gillett, Vice-Admiral O.F. Southsea	1919–21
G., A.S. (w)	1910	Gilligan, Barbara (Mrs David Carr) Starston	1946–8
Gaastra, John Norwich; Cringleford	1949–51	Gillingwater, Robert (w) Norwich	1903–5
Gadsby, Miss Jean Hevingham; Norwich	1952–4	Girling, Miss Eleanor M. (w) Holt	1901–5
Gales, Henry Acle	1888–9	Goddard, Fay (c) Kirstead Green	1976–2003
Gales, Miss Ruth Acle	1891–2	Goddard, Jack Lowestoft	1946–58
Gandy, Kathleen Norwich	1972–84	Goldie, T. Inglis (w) Norwich	1896–1904
Gardiner, Miss A.M. (w) London	1898	Goldsworthy, Mark Norwich	1987–90
Gardiner, Graham S. Wisbech	1934	Gooch, Alexander J. Lowestoft	1947–50
Gardner, Miss E.M. (w) Sheringham	1923–6	Gooch, Mrs Annabel Market Weston	1949–53
Garrett, Mrs Dorothy Ipswich	1952–86	Gooch, M. Wymondham	1946
Garrod, Reginald Percy Little Melton	1959–72	Gooch, Peter Hayden Norwich	1949
Garry, Joan Norwich	1992–98	Good, Mrs Marjorie V. Norwich	1970–83
Gascoigne, Mrs Old Catton	1906–10	Goodchild, Mrs B. Colney	1935–7
Gathergood, Miss May E.M. Rockland St Andrew	1917–19	Goodchild, Mrs Beryl C.M. Norwich	1963–6
Gathergood, Miss Milicent E. Rockland St Andrew	1917–19	Goodman, J. Reginald London; Marsham	1895–1910
Gay, Janet Gwendoline Norwich	1977–8	Goodman, Mrs J.R. Marsham	1909–10
Gaze, Miss Lily E. (w) Norwich	1901–3	Goodman, Mrs Kathleen Sheringham	1949–52
Gaze, Susan Thurton	1981	Goodson, Christine Wymondham	1995–97
Geeson, Ted (c) Old Catton	1995–97	Goodson, Douglas Wymondham	1995
Geldart, Miss Alice M. Norwich	1906–24	Goose, Miss E.E. (w)	1893–6
Gentle, Bernard Blofield	1946–62	Gordon, C.F.W.	1972
Gentle, June Norwich	1994	Gordon, Les (c) Norwich; Bungay	1964–2001
Gerrard, Mrs Doris North Elmham	1966–7	Gosselin, Mrs M.B. Hindringham	1908–13
Gibbs, Mrs Dorothy A. (cw) Norwich	1926–31	Goulding, William Art. Norwich	1996–2002
Gibson, Mrs E.M. Roughton	1934	Gowen, H.J.T. (c) Thorpe	1929–32
Gibson, Miss J. London; Roughton	1937–8	Gowen, Miss Margaret A. Thorpe	1932
Gilbert, Mrs Edwin Ashby	1910–23	Gowen, Norma Hellesdon	2000–03
Gill, Diane Hellesdon	1996	Goy, Miss Enid Brundall	1970–71

Grace, Miss Lily (w)	1910	Hamond, Miss Gertrude Norwich	1908–12
Grace, Miss M. (w)	1910	Hand, Miss Margaret R.K. Norwich	1911–22
Graham, George Wroxham	1927–9	Hann, Christopher J.	1973
Green, Catherine (w)	1893	Hannaford, C.E. Wroxham	1927–9
Green, Miss H.F. London	1921–3	Harbord, Miss Phyllis Norwich	1915–17
Green, Roland Hickling Broad	1947–66	Harcourt, Bosworth (w) Norwich	1898
Green, R.W. Aylmerton	1938	Hare, Gerald D. Norwich	1960–75
Gregory, Miss Anne Lower Hellesdon; Norwich	1959–62	Hare, Reginald G.D. Norwich	1963–4
Gregory, Brenda J. Mulbarton	1979–88	Harper, Fred Norwich	1971–3
Gribble, Mrs Eleanor M. Harbourne; Ipswich	1932	Harper, Mary Norwich	1986–2002
Griffiths, Tom (c) Croydon; Norwich	1933–89	Harrison, Charles Harmony Great Yarmouth	1886–8
Grimble, John Boston	1947–56	Harrison, Coela Elizabeth le Strange Pryce London; Norwich	1951–2
Groom, Miss Mary Wenhaston	1953	Harrison, Mrs Frederica Hainford	1959–64
Gundry, Mary Stradbroke	1991–92	Harrison, Janet (c) Norwich	1983–2003
Gurney, Hon. Mrs Old Catton; Caistor	1910–14	Harrison, John Cyril Hainford	1946–64
Gurney, Lady Sprowston	1911–15	Harrison, Miss Josephine Olivia Hainford	1952–5
Gurney, Mrs Sprowston	1905–9	Hart, Mrs Gwendolyn Norwich	1963–89
Gurney, Miss Agatha Keswick	1900–5	Hart, Michael J. Norwich	1968–74
Gurney, Gerard H. Keswick	1900–12	Hartwell, William Norwich	1949–50
Gurney, Miss Helen Thickthorn; Eaton	1897–1919	Harwood, Miss Lucy Upper Layham	1946–8
Gurney, Miss Pamela Northrepps	1948–75	Hauser, Dorothy P. Burston	1983
Gurney, Miss Rosemary Narborough	1936–7	Havers, Mrs Charles – see Buckingham, Miss Ethel	
Gurney, Timothy S. Horstead	1957–61	Haward, Birkin Ipswich	1949–52
		Hawke, Jean Aylsham	1998
Hairsine, Mrs Betty Coltishall	1970	Hawker, Gareth (c) Norwich	1974–92
Hall, Miss D.C. Norwich	1938	Hayden, F.H. Norwich	1904
Hall, J. Norwich	1917–21	Hayward, F.W. (w)	1896
Hall, Marjorie Carbrooke	1981–94	Hazard, Mrs Pulham St Mary; Harleston	1899–1903
Halliday, Frank (c) Felthorpe	1994–98	Heinz, Jacob Coltishall	1947
Hammond, Mrs Margaret E. Hethersett; Sprowston; Thorpe	1952–69	Herbert, Hon. Mrs Elaine (c) Norwich	1948–55
Hamond, Mrs Diana (c) Morston	1928–38	Heriz-Smith, Miss Gillian Lewis Mitford Kessingland	1959

Herries, Mrs L. Norwich	1933–4	Hope, Mrs Adrian C. London	1897–1904
Herring, Miss Elsie le Strange Narborough	1906–10	Hopkins, Eric Cromer	1987
Herring, Ralph Ipswich	1964	Hopkins, Marshall Poringland	1994–96
Heslop, Gerald G. Cringleford; Eaton	1909–12	Horovitz, Armin Norwich	1946–8
Hight, Arthur E. (w) Thorpe	1900–5	Houghton, Susan Norwich	1976–7
Hill, Miss Adele (w)	1912–13	Houston, Ann (c) Norwich	1999–2003
Hill, Clare (c) Sparham	2003	Houston, Ian North Walsham	1965
Hill, Mrs Lucie Norwich	1960–65	Howard, Desmond W. Banham	1957–9
Hilton, Rebecca Kenninghall	1980	Howard, Richard C. Norwich	1960–68
Hine, Mrs Victoria S. St Alban's	1889	Howell, Mrs P. Waltham Abbey	1938
Hines, Edward S. (c) Old Costessey	1948–74	Howell, Mrs Philip Camberley	1912
Hines, Judy (c) Old Costessey; Briston	1984–87	Howes, Allan London	1920–23
Hipkin, Miss Janet Norwich	1954	Howes, Miss Gertrude C. (w) Norwich	1886–92
Hitchcock, H.F. (w) East Bergholt	1906–8	Howes, Miss Laura (w) Norwich	1903–5
Hoare, Edward B. London	1897	Howitt, Sidney Felix (c) Norwich	1888–1909
Hoare, Miss M. Cromer	1886	Howes, Miss Phyllis (w)	1913
Hobbis, Charles Iredale Norwich; Fenstanton	1934–51	Howlett, Graham Norwich	1978–89
Hobbis, Charles W. (c) Norwich	1916–53	Howlett, Miss Rosa (w) Bracondale	1897–1914
Hogan, Mrs K.L. Horsford	1933–8	Hudson, Miss Gertrude Whinburgh	1937–74
Hogg, Miss Mary Blofield	1971–5	Hunt, John Norwich	1989–91
Holborow, John Keswick	1963	Hunter, Leo North Elmham	1989
Holdsworth, Joseph Benhall	1966–9	Hunter, Patricia North Elmham	1989
Holdsworth, Maurice J. Benhall	1963–73	Hurr, Ben Great Massingham	1970–73
Holgate, Anne Norwich	1994	Hurr, Maurice Lowestoft	1968–9
Hollingsworth, Edna Norwich	1990–91	Hussey, Elizabeth Tivetshall St Mary	1988–91
Holloway, Joy Mettingham	1979–83	Hutchinson, Derek (c) Lower Hellesdon	1959–81
Holman, G. Elliott East Dereham	1934–8	Hutchinson, Mark Lower Hellesdon	1977–9
Holmes, Henry A. (w) Norwich	1901–4	Hutt, Mrs H.R.M. Crostwick; Somerset	1904–8
Holmes, Miss Margaret Norwich	1896–1913		
Holmes, Robert George Lower Hellesdon	1957–61	Ireland, Laura Wymondham	1983–92
Hoodless, H.T. Norwich	1937		

Jackson, Dowager Lady Raveningham	1967	Joyce, Stephen Sprowston	1990
Jackson, Frederick (w)	1908–10	Jupe, Margaret Tharston	1984
Jackson, Gwen Old Costessey	1981		
Jackson, Mrs Jill (c) – see Phillips, Jill		Kane, Mrs Betty Thorpe	1965–7
Jackson, Miss Winifred H. Diss	1916	Kauffman, Juliet Wroxham	1998
Jacob, John Thorpe	1965	Kearney, Patrick Neville Cley-by-Sea	1952–6
Jacobs, John Thorpe	1967	Keath, Bernard (c) Lingwood	1989–2000
Jacques, Maureen Burgh St Peter	1978–9	Keeling, Pegaret Norwich	1950
Jagg, Miss Helen (w) Felbrigg	1928	Keir, Mrs J.L. Aldborough	1904–8
James, Deirdre Hethersett	1987–2000	Keith, F.T. Lingwood	1899
James, Kenneth Hethersett	1987–2000	Kemsley, Walter Norwich	1947–88
James, Mavis Brooke	2003	Kendle, Mrs Margaret Norwich; Chedgrave	1949–66
James, Robert Brooke	2000–03	Kennaway, Miss Ruth L. Garboldisham	1908–11
Jameson, Mrs R. Blakeney	1934	Kennedy, Mrs Doris M. Thetford	1964
Janes, Miss M. Morston	1937	Kennedy, Robert Thetford	1962–3
Jannock, Miss Vena (w) Dersingham	1898	Kennett, Lady London	1946
Jay, Peter Norwich	1947	Keppel, Miss F. (w)	1912–13
Jay, Oliver Norwich	2002	Keppel, F.A. Overstrand	1946
Jepson, Kenneth S. (c) Thorpe	1983–2003	Keppel, I.F.A. (w)	1912
Jerwood, Mrs Barbara Joan Norwich	1962–9	Kerr, David Ord (c) Forncett	1983–85
Jewson, Mrs Annie Lower Hellesdon	1929–54	Kerridge, A.D. Reepham; Mundesley	1929–46
Jewson, Mrs Betty Bracon Ash	1974–80	Kerridge, Roy R. Stowmarket	1969–71
Jewson, Mrs J.C. Lower Hellesdon	1935–6	Kerrison, Mrs Jessie Aylsham	1906–24
Johnson, Elsie V. Thorpe	1950–53	Kettle, Mrs Mary A. Southwold	1960–64
Johnson, Miss Gillian De Carle Stoke Holy Cross	1974–5	Kibbler, Arthur K. Thorpe	1952
Johnson, Mrs Kathleen Norwich	1965	Killingbeck, Mrs Trudy Norwich	1970–77
Johnson, Keith (c) Framingham Earl; Sprowston	1966–2003	Kinder, Mrs Margaret C. Thorpe	1919–26 *
Johnson, Mrs Mary (c) Norwich; Stoke Holy Cross	1951–84	King, Miss Agnes Gardner Hartwell	1907–21
Johnstone, Miss Gwyneth Great Hautbois	1933–8	King, Miss E.T. Hartwell	1907–10
Jones, Mrs D.M. Norwich	1936	King, Francis H. (w) Holt	1924–7
Jones, Nigel Gwyn Colton; Wicklewood	1965–73	King, George A. (c) Norwich	1887–1909

King, Pat Old Costessey	1977–80	Lee, Mrs Marion Stella High Kelling	1949
King, Mrs S.K. Reepham	1936	Lee Warner, Miss Gladys (w) Harleston	1924–33
Kirk, Mrs Lavina May Norwich	1946–53	Lefever, Geoffrey King's Lynn; Dersingham	1963–9
Kirk, Roger Cringleford	1989	Leider, Miss Daphne Easton	1949
Kitchin, Mrs W.E. (or J.) Norwich	1935–6	Le Maistre, F.W. (w)	1912
Kitton, Frederic G. London; St. Albans	1887–9	Leney, Frank (c) Norwich	1928–37
Knight, Miss Gladys D. Leziate	1928–36	Leslie, Dr John (c) Norwich	1975–81
Knights, Edward John Hellesdon	1967–8	Levien, Bette Norwich	1978–96
Knights, Jonathan A.C. Eaton	1986	Levien, Louie B. Norwich	1986–90
Knights, Reginald W. Shadingfield	1951–6	Lewis, Mrs (w) Belaugh	1901
Knowles, William Taverham	1988–90	Lewis, Bernard Rollesby	2000
Kratschkoff, Dimitri Aylsham	1963	Lewis, Miss Marjorie Old Costessey	1970–2000
		Limmer, M. Bixley	1946
Lacey, Arthur J. Norwich	1902	Lindley, Hon. Miss Constance East Carleton	1899–1908
Laird, S.R. Norwich	1946	Linnell, Lawrence G. (cw) Letheringsett	1922–53
Lambourn, George Brooke	1932–4	Livock, Miss W. Horsell	1933
Large, William (w) Norwich	1913–37 *	Loan, Jill Old Catton	1978
Larkin, John	1973	Loan, T. (c)	1980–81
Lascelles, Sir Daniel W. Holt; Cley	1947–66	Long, Mrs G.V. (w) Norwich	1924
Lascelles, Miss Susan O. (c) Swanton Novers; Holt; Cley	1933–76	Longe, Miss Julia Spixworth	1901–10
Latta, Mrs Fiona Westacre	1967	Lord, Herbert L. (w) Norwich	1903
Laurance, Martin (c) Norwich	1990–2000	Looker, Mrs Agnes A. Norwich	1954–78
Law, Miss Aileen London	1947	Love, E. Shipdham	1935
Lawrance, Suzanne Alderford; Norwich	1991	Loveday, John Old Buckenham	1949
Lawrence-Jones, Miss Hester Fakenham	1904–5	Lovett, Miss Doris (w)	1912–13
Laws, Kiturah Sprowston	1986–2003	Lowe, C.L. (c)	1934–45
Lawton, Lt Col Frederick M. Aldborough	1969	Lowe, Mrs Doreen Merica Norwich	1959–60
Laycock, Allan B. (c) Norwich; Colney	1951–74	Luard, Miss Lilian Witham	1898–1902
Leach, Mrs Jessie Salthouse; Cley	1949–66	Ludovici, A. (w) London	1904–5
Lee, J.W. Norwich	1946	Lumb, Miss Gwendolen Marsham	1905–8
Lee, Kathleen (c) Norwich	1977–80	Lund, Dr K.F. Mundesley	1938–46

Lyle, Miss Mary (Mrs Dodson) (w) Norwich	1929–33	Marshall, George (w) Brundall	1904
Lyon, Kenneth West Runton	1949–53	Marshall, J. Miller (c) Norwich; Teignmouth; Clifton	1885–1904
		Marshall, P.P. Bracondale	1885
Mabey, Heather Norwich	1978–2002	Marsham, Miss Cara Hevingham; Aylsham	1946–53
McArdle, Harry Strumpshaw; Chesterfield	1991–2003	Martin, L.C. (w) Beckenham	1926
McCubbin, Mrs Mary Alice Taverham	1962–71	Martin, W.A.H. Ledbury	1909–15
MacDonald, Miss Katherine B. Norwich	1965	Marvin, Miss Forbes (w) London	1902–3
McDougall, Keith Lakenham	1978	Marwood, Shirley Wymondham	1982–90
Mace, Brenda Thorpe St Andrew	2003	Maslarova, Violeta Norwich	1978
McEwen, Miss Mary Norwich	1954–62	Mathews, Mrs F.C. Brockenhurst	1937–8
Macfarlane, Jane Rackheath	1998	Maude, W. (w)	1923
McFeeters, Noel Bungay	1991	Maxwell, Jonathan Hellesdon	1998
McGhee, Angela (Mrs Stannard) Horning	2002	May, Adrienne (c) North Walsham	1998–2003
Mack, Miss Monica Paston	1906–7	May, J. Graham (w) Norwich	1898–1902
Mackenzie, H.A.O. Scole	1886	Mayhew, Mrs M.R. (c)	1978
Maclean, Pauline Norwich	2002–3	Meadows, Bernard London	1951–2
McLaren, Alan R. Frostenden	1947–50	Meikle, A.J. Diss	1938
MacNaughton Jones, Miss Kathleen Dereham	1932	Melinsky, Renate Norwich	2001–03
Maddison, Miss Annie E. (w) Lowestoft	1905–8	Mellon, Campbell A. Gorleston	1926
Maggs, Carla Norwich	1996	Mellor, Mary Mulbarton	1978–89
Maidment, Dr Frederick N.H. (c) Harleston	1946–57	Mercer, Kenneth Bury North Walsham	1954–7
Mallin, Muriel Lowestoft	1994	Merriken-Smith, Miss Evelyn (w) Norwich	1926
Malmstrom, Miss Anne (Mrs Holgate) Aslacton	1976	Metcalf, Betty Norwich	1998
Mann, Miss Fairman (w)	1907	Metcalf, Peter Caister-on-Sea	2000
Mann, Marro Norwich	1992	Meyer, B.P. Norwich	1946–7
Mann, Miss Mary Bertie (w) Shropham	1908–11	Meyrick, Miss Myra H. Blickling	1905
Margarson, Miss K. (w) Wendling	1902	Michalski, Mrs Sheelah (c) Framingham Earl	1965–83
Maris, Miss L.M. Overy Staithe	1938	Middleton, Miss Ann Rosemary Aylmerton	1948–50
Marjoram, William (w) Gorleston	1902–7	Middleton, Mrs Marion Aylmerton	1936–50
Marsh, C.F. Ludham	1891–2	Middleton, Mrs Merril Joan Tilney All Saints	1965–6
Marsh, David Taylor Drayton	1970	Miller, Miss Rugby	1899

Miller of Glenlee, Lady (Audrey) Holton St Peter; Westhall	1976–94	Morris, Cedric Hadleigh	1946
Miller, Miss Doris Norwich	1957–70	Morris, Ena M. Old Catton	1976–92
Miller, Hubert A. Norwich	1906–38	Morris, Jean (c) Thorpe St Andrew	2001–03
Miller, Inga Priestman Sedgeford	1995–2001	Morritt, Mrs M. Mary (c) Norwich; Old Costessey	1957–69
Miller, Miss Norah Rugby	1899	Morse, Mrs A.F. Earlham	1906–14
Miller, Miss Philippa Ruth Sprowston; Norwich	1933–76	Morse, Mrs Annabel M. (c) Coltishall Mead	1930–56 *
Miller, Stanley L. (c) Lower Hellesdon	1956–74	Morse, Miss Dorothea G. Norwich	1903–9
Mills, Miss Dorothy (w) Norwich	1904	Morton, Cavendish (c) Eye	1951–67
Milner, Stuart (c) Tasburgh; Thrandeston	1963–8	Mossman, Penny Hoveton	2003
Milnes, W.H. Polstead	1932	Mottram, A. Hugh Bracondale; London; Llandaff	1907–14
Mindham, Dorothy (c) Thorpe	1981–91	Mottram, Barbara (c) Brundall	1989–2001
Mitchell, Angela East Dereham	1989–90	Mould, Maura (c) Taverham	1994–2000
Mitchell, Gillian Letheringsett	2002	Moulton, Carolyn Hempnell	2003
Moffit, Brenda Norwich	1995–98	Moyle, Mrs Olive Millicent Norwich	1934–71
Monck, Nugent (cw) Norwich	1928–31	Mueller, Max Swaffham	1968–80
Monier-Williams, Hugh Beynon (c) Southwold	1966–84	Mueller, Mrs Winifred Swaffham	1970–82
Monier-Williams, Mrs Madeline (c) Southwold	1966–83	Muller, Mark Cologne, Germany	1978–80
Monkhouse, Miss Violet (w) Cambridge	1904	Mumford, L.C. (w)	1913
Montgomerie, Miss Mary Molineux Garboldisham; Norwich	1902–13	Munnings, Alfred J. (cw) Norwich; Harleston; Swainsthorpe; Dedham	1897–1934
Moore, Miss Evelyn F. West Runton; Cromer; Sheringham	1899–1927	Murray, Mrs G. Thetford	1938
Moore, Leslie L.H. (c) Old Catton; Cringleford	1935–61		
Moore, Miss M.M. Ditchingham	1934–8	Naunton, William Johnson Smith Thorpe	1957–9
Moore, Miss Olive L. (w) Norwich	1913–18	Naylor, Francis I. Sheringham	1967–8
Moore, R. Norwich	1946	Negal, Patrick	1973
Moore, Sidney (w) Norwich; Kirby Bedon	1938–57 *	Neville, Miss B. Amy Sloley; London	1901–15
Mordin, Henry (c)	1964–8	Neville, Miss E. Kate Sloley, London	1906–14
Mordin, Herbert Thorpe	1962–73	Newcomb, Mrs Mary Needham	1951–63
Morgan, Miss Kathleen (w)	1905–8	Newton, Miss Phyllis K. (w) Worstead	1917–23
Morgan, Miss Margaret J. Keswick	1967–9	Nicholls, J.F. (w) Norwich	1924
Morgan, Owen London	1907–8	Nichols, Miss Catherine Maude (w) Norwich	1885–1922
Morgan, Richard Henham	1971	Nichols, Frank Beeton (c) Norwich	1953–78

Nix-James, Miss Katharine Norwich	1961–9	Page, Henry Bridgham	1991
Norman-Crosse, Mrs W. (w) Framlingham	1924	Page, John Blakeney	1934–5
Northey, Miss G.C. Lower Hellesdon	1935	Page, Peter A. Sheringham	1981–87
Norton, Maureen J. Norwich	1977	Page, Revd Reginald C. Trimingham	1913–56 *
Noyes, Elizabeth Norwich	1998	Paine, Mrs Jill (c) Great Melton; Fressingfield; Norwich	1947–2002 *
Noyes, Jean Norwich	1980–2002	Painter, June Norwich	1998
Noyes, Pamela Burnham Overy Staithe	1992	Palfrey, John James Norwich	1953–9
Nurse, Charles Baxter (w) Norwich	1887–1909	Palmer, Clement Great Yarmouth	1904–5
Nutting, Miss K.M. North Walsham	1937	Palmer, Mrs Muriel Drayton; Norwich	1954–72
		Pan, Arthur London	1949
Oakes, Major John Bury St Edmunds	1949–58	Parker, William Hellesdon	1995
Oakley, Joseph Little Plumstead	1984	Parr, W. Henry (w) Norwich	1924–7
Oates, Bennett (c) Little Plumstead	1983–95	Parry, D.H. Overstrand	1928–30
Oates, Michelle Bennett Little Plumstead	1984–87	Parsons, Diana Pitt (c) Norwich	1987–97
Odell, Mrs Isabel M. (w)	1923	Parsons-Norman, Miss Pattie E. (w) Norwich	1912–16
O'Donnell, Mrs Vaughan Dereham	1969	Partridge, Alwyn Yelverton	1969
Offord, Miss Georgina E.W. (cw) Norwich	1900–26	Partridge, Miss Blanche Hunstanton	1906–19
Offord, Miss Gertrude E. Norwich	1896–1904 *	Partridge, Francis F. Forncett St Peter	1964
Ogden, Mrs A.B. (c) Norwich	1965–9	Partridge, F.H. Hunstanton	1915–27
Ogden, Albert Booth (c) Norwich	1960–73	Partridge, Miss Janet R. Hunstanton	1928–38
Ogden, Miss Irene (c) Norwich	1948–2003	Passmore, Miss Dorothy (Daisy) Wroxham	1920–33
Ogden, John (c) Chedgrave	1991–97	Patteson, Miss Marion F. Cringleford; Cromer	1901–27
Ogilvie, James R. Eaton	1982–86	Payze, Barbara Dereham	2000–03
Oliver, Benjamin Ipswich	1932	Peake, F.G.G. Norwich	1935
Oliver, Kenneth Herbert Eaton; Cheltenham	1947–76	Pearson, R.C. Hunstanton	1927–36
Oliver, Miss Mary B. Letheringsett	1971	Peck, Miss Marian F. Smallburgh	1946–54
Osborne, Andrew M. Taverham	1982–85	Pedley, Peter (c) Saxlingham	1977–82
		Peebles, John Stewart Lowestoft	1989–2003
Packe, Anthony A. (c) Norwich	1982–2001	Pellew, Claughton Southrepps	1949–52
Padgett, A.J.B. (w) Norwich	1928	Pennett, Mrs Nora C. Boston, Lincs.	1946–50 *
Page, Christopher T. King's Lynn	1921–3	Penny, Christopher Bury St Edmunds	1984

Penton, Alan C. Reepham	1953	Pleasants, Brian North Walsham	1997
Peplow, Mrs A. Postwick	1954	Plummer, Pauline (c) Honing	1991–2002
Percival, Miss Edith M. Peterborough; Sheringham; Norwich	1901–36	Plumstead, G.A. Sprowston	1946
Perks, Christopher G.H. Norwich	1946–50	Pocock, T.W. (w) Old Catton	1896–8
Perowne, Miss Diana Brooke	1967–73	Pollock, Jane Beccles	1991–96
Perowne, Miss J.E. Starston	1932–4	Pond, F.J. Norwich	1946
Perry, Stanley Felixstowe	1987–89	Porter, Miss Marjorie Isobel Fakenham; Burnham Market	1930–86
Peters, J. (w)	1896	Potter, Mrs Albani Norwich	1964–9
Petherick, Miss Sybil G. Hopton	1904–7	Potter, David J. Loddon	1982–2003
Pettitt, Mrs B.H. (c) Norwich	1949–58	Powdrill, Kenneth S. J. Norwich	1958–9
Pettitt, David W. Glynn Norwich	1952–3	Powell, Heather Harcourt (c) Eaton	1985–2001
Pettitt, Wilfred S. (c) Great Yarmouth; Reedham; Norwich	1920–65	Powell, Miss Stratton Strawless	1903–4
Pfob, Mrs L.M. Little Melton	1962–4	Pratt-Green, Revd Fred Thorpe	1970
Phillips, Mrs H.M. Beccles	1937	Precious, Miss J.E. (w) East Dereham	1935
Phillips, Jill (Mrs Jackson) Norwich; Brandon Parva	1979–2002	Prentice, Charles Ipswich	1932
Philo, Nicola Dereham	1989	Presents, Philip R. (w) Lakenham; Norwich	1891–2
Pickering, Frank Reginald Sprowston	1961	Preston, Miss Hilda Aimee Lowestoft	1914–23
Picton-Fox, D. Norwich	1936–7	Pretty, Mrs Peggy N. Ipswich; Stowmarket	1970–79
Picton-Fox, Mrs D. Belton; Norwich	1933–7	Prickett, Miss Dorothy Browston	1907–16
Pigg, J.W. (w) Norwich	1903–5	Primmer, Miss Kathleen Stowmarket	1954–5
Pigott, Miss Blanche Sheringham	1902–6	Prior, Col B.H.L. (w) Thorpe	1937–8
Pilch, Miss Rosa Norwich	1957–61	Prior, Miss Margaret C. Norwich	1912–15
Pilgrim, Miss Hilda Hatfield	1951–5	Puddy, Dr Eric Ivimy (c) Gressenhall	1947–67
Pilgrim, Leonard W. Norwich	1949–54	Puddy, Miss Susan C. Gressenhall	1955–66
Piper, Derek Swanton Morley	1983	Purcell, D.C. Norwich	1933–5
Piper, Mrs Frank Belaugh	1907–10	Purchas, Huw Wells-next-the-Sea	1994–2000
Piper, Ian Norwich	1988–92	Pytches, Mrs Ruskington	1924
Piper, Roland James Norwich; Ingoldisthorpe	1953–6		
Platt, Harry Blofield	1984–90	Quantrell, Mrs Ada V. Norwich	1959
Platt, Ruth Norwich	1950		
Platten, Miss B. (w) Great Yarmouth	1902	Raby, George A. Norwich	1934

Rackham, W. Leslie (w) Norwich	1893–1903	Ringer, James Norwich	1952
Rae, Derek (c) Brooke	1986–94	Riviere, Dr B.B. Woodbastwick	1935–6
Raistrick, Miss Katherine M. Norwich	1959–66	Roberts, Mr (w) Tring	1904
Ram, Miss J. Adye (w)	1923	Roberts, George E. Loddon	1957–66
Ransome, Miss Elizabeth Scole	1956–7	Robertson, Henry (w) Norwich; Hastings	1900–8
Ransome, Russell Griffiths Norwich	1949–51	Robertson, J.B. Hellesdon	1934–6
Rawlinson, Miss Anna Hempnall	1964–5	Robertson, Mrs Merrie B. Norwich	1950–69
Ray, Fred H. (c) Norwich; Thorpe	1885–1907	Robertson, Michael R. Norwich	1949–54
Raywood, Tricia Norwich	1996	Robertson, Miss Peggy V. Norwich; Taunton	1947–51
Redfern, Anne	1972	Robertson, Percy (w) London	1904
Rees, Miss M.T. Southwold	1938	Robertson, Mrs R.B. Norwich	1937–55
Reeve, Clarence Mettingham	1962–7	Robinson, Miss Cambridge	1902–3
Reeve, Mrs D'Arcy Marlow; Matfield	1896–1904	Robinson, John Brian (c) Rackheath	1963–2003
Reeve, Miss Diana Rose Mettingham	1949–67	Robinson, Jean Brooke	1986–95
Reeve, James Norwich	1885	Robinson, Miss Mary Stewart Cambridge	1915
Reeve, John Felthorpe	2002	Robinson, Mrs Pauline Norwich	1965–6
Reeve, John Constable Mettingham	1949–66	Roche, Col Walter Tasburgh	1910–12
Reeve, Miss Joyce D.M. Norwich; Cherry Hinton	1968–71	Roe, Miss Felicity Norwich	1964–5
Reeve, Russell S. (w) Norwich; London	1919–32	Roe, Miss Muriel Gordon King's Lynn; Leiston	1906–9
Reid, Dr E. Stewart (w) Blakeney	1928–47	Rogers, Mrs Mary G.H. Kirkley; Coltishall	1912–24
Renton, Constance North Walsham	1992	Rogers, Miss Rose S. Holt; Belton	1889–1934
Reynolds, Bernard R. (c) Norwich; Washbrooke	1946–54	Romero, Miss Blanche Cromer	1920
Reynolds, Juliette Norwich	2003	Roofe, Russell T. Norwich	1949–60
Ribbands, Edward J. Thorpe; Cromer; Norwich	1946–73	Rope, George T. Wickham Market	1894–9
Rice, Edgar Thorpe	1920–22	Rose, Mrs Grace Emilie (Biddy) Heacham	1959
Rice, H. Amos Norwich	1949–52	Ross, Mrs A.M. Norwich	1903–8
Rice, Miss Pauline Norwich; Cringleford	1952–64	Ross, Tracey (c) Old Catton	1997–2003
Riches, K.B. (c)	1931	Rosser, Mrs C.S. (w) Marlingford	1901
Richmond, Sir William B. (w)	1904	Roth, Arnold Lamas	1969
Rider, Graham (c) Norwich	1990–2000	Rothwell-Jackson, Christopher Cringleford	1953
Rider Haggard, Mrs A. Ditchingham	1937–53	Rowbottom, John East Beckham	1987

Rowsell, Miss Irene Beccles	1902–9	Seymour, Mrs Dorothy V. Thelnetham	1964–70
Rowsell, Revd T.N. London	1907–8	Seymour, William (c) Attleborough	1980–90
Rudd, A.J. Norwich	1934	Sforza-Cox, Dr Bianco Old Catton	1984
Rudd, A. Kingston Wolferton	1905–24 *	Shaw, Frederick H. Norwich	1949
Rudd, H.R. Kingston Attleborough	1937–8	Sherman, Mrs Eugenie Harleston	1955–8
Rudd, Louis E. (w) Norwich	1928–33	Shingles, Joyce Thorpe St Andrew	1995–2003
Runnels-Moss, Mrs Maeve Veronica Norwich	1954–7	Shreeve, Dorothy Hellesdon	1972–82
Rush, Hazel New Buckenham	1996–97	Shuker, Mrs Day Wisbech	1952–6
Rushton, Raymond Norwich	1952	Sidebottom, Norman (c) Norwich	2002–3
Russell, Fred (c)	1926–30	Sinclair, Meredith Hethel	1977–9
Rustad, Elizabeth East Dereham	1989–90	Sivell, Mrs Vreena (c) Norwich	1951–88
Rycraft, Horace A. (c)	1982–4	Skelton, Miss Kathleen (Kay) (Mrs Spelman) (c) Horsford; Kirby Bedon	1934–79
Ryder, Colin Norwich	1982	Skelton, Miss Margaret Norwich	1899–1900
Rynd, Miss W.L. Norwich	1909–10	Skinner, E.F. Ludham	1892
		Skinner, James Hay Mclunes East Carleton	1959–62
Sadd, Miss Irene A. (w) Norwich	1928–31	Slatford, Mary Needham	1949
Sage, Mrs Faith K. – see Boswell, Miss Faith K.		Smeaton, Miss Lilian E. (w) London	1901
Sandford, Mrs K.S. (w) Cromer; Maidenhead	1890–1938	Smee, Alfred John Norwich	1948–56
Savory, Miss E. (w) Sparham	1898	Smith, E.F. de Carle Thorpe	1933–7
Scales, Miss Edith M. Monks Eleigh	1954–62	Smith, G. Overy Staithe	1946
Scantlebury, Laurence (w) Norwich	1923–4	Smith, Gordon H.J. Thorpe	1980
Scarlett, Mrs Maude Sprowston	1963–71	Smith, Mrs Gwendolen Matthew Overy Staithe	1952–3
Scott, Ernest Bury St Edmunds	1949–57	Smith, Mrs G. Salmond Overy Staithe	1935–50
Scott, T.J. (c) Norwich	1887–1919	Smith, Joyce Sutherland Norwich	1997–99
Scott, Walter (c) Norwich	1890	Smith, Miss K. de Carle Thorpe	1934–8
Scott-Moncrieff, William Norwich	1964	Smith, Miss Marion S. (w) Briston	1928
Scratchley, Miss M.C. East Hendred	1937	Smith, Marjorie F. Cromer	1981
Seago, Edward Brian (w) Brooke	1926–32	Smith, Miller (w) Thorpe	1885–7
Seago, Miss Ellen May London; Trimingham	1912–3	Smith, Mrs Nellie Hellesdon	1973–4
Seaman, Saxon Costessey	1987–90	Smith, Philip John Sheringham	1954
Searle, Frederick Thomas Old Catton; Poringland	1961–92	Smith, Roland G. Wymondham	1951–2

Smith, Miss Rosemary J. (c) Norwich	1974–98	Steward, E.S. Bertram (w) Norwich	1893–8
Smith, William John Norwich	1957	Steward, John H. (c) Norwich	1933–69
Smolicz, Ryszard A. Norwich	1952–3	Steward, Mrs Mary Oulton Broad	1965
Smyth, Owen Paul (cw) Norwich	1928–51	Stewart, Dennis Old Catton	1963
Snelling, Miss Enid (w)	1912–3	Stewart, Geraldine Aylsham	1992
Soanes, Arthur E. Gisleham	1946–7	Stimpson, Percy E. (w) London	1895–1901
Solberg, Kali (c) Norwich	1996–97	Stocker, Anthony Norwich	1980–86
Soper, John Chedgrave	1962–75	Stone, Peter John Old Catton	1953–4
Southwell, W.C. Swaffham	1892	Stracey, Miss Hilda Sprowston; Rackheath	1906–9
Sowels, Miss Ethel J. Thetford	1902–4	Stracey, Miss Rosalind London; Walberswick	1952–7
Spalding, Mrs Margaret (c) West Winch; Hingham	1964–73	Stratton, David Norwich	1963
Speakman, Malcolm I. Poringland	1979	Strauss, Mrs H.G. London	1936–7
Spelman, Mrs Kathleen – see Skelton, Miss Kathleen		Sturgeon, Miss Kate (w) Thorpe	1896–1915
Spencer, Noel (c) Norwich	1946–75	Suffield, The Lord Dereham	1983
Spencer, Mrs Vera Kathleen (c) Norwich	1947–79	Sullivan, Michael (c) Taverham	1999–2002
Spink, Dorothy West Earlham	1976–2003	Sullivan, Patricia (c) Taverham	2001–2002
Spragge, Rebecca Norwich	2001	Swanton, Dorothy (c) Diss	1985–90
Spriggs, Ron Norwich	1989	Sully, Mrs Kathleen Fakenham; Crimplesham	1971–6
Squirrell, Revd Harold S. Cromer	1916–9	Swindells, F.G. Costessey	1938
Squirrell, Leonard Ipswich	1932	Symington, Mrs Antoinette A. Stanhoe	1946–69
Stanbury, Captain W.H. (w) Thorpe	1905–8		
Stannard, H. Sylvester Flitwick	1906–9	Talks, David (c) Norwich	1988–2003
Stannard, Phillip Horning	2002	Tall, Miss Mary Norwich	1959–62
Stansby, Miss Rosemary London	1964	Tallack, Mrs Rosalie (w) Norwich	1887–1909
Stark, Arthur James Redhill	1887–93	Taunton, John Francis Thorpe	1961–8
Starksfield, Stanley Norwich	1980–87	Taylor, Arthur Drayton	1998
Starling, Miss Dora Norwich; London	1903–7	Taylor, Miss Edith S. Norwich	1948
Starling, H. James (c) Norwich	1933–96	Taylor, John Taverham	1996–97
Starmer, Miss Edith E. (cw) Mundesley; Norwich	1906–47	Taylor, Mrs Mary Josephine Morton-on-the-Hill	1962
Steggles, Walter J.	1973	Taylor-Marsh, John David Drayton	1969–85
Stevens, Dr Henry Potter Redisham	1946–60	Taylor, Paul Eaton	1997

Name	Date	Name	Date
Teesdale, Christopher Coltishall; Lamas	1895–1928	Upcher, Cecil Norwich	1949–55
Tennent, Miss Kechie Southrepps	1951–2	Upcher, Miss Violet M. Fritton	1909–14
Thackwell, Dr (c)	1947	Upsher, Deborah Norwich	1996
Thackwell, Mrs Mary Norwich	1936–52		
Theobald, Miss Hilda Dereham	1947–76	Van Der Reyden, Mrs Gwendoline M. Norwich; Strumpshaw	1967–73
Thickett, Keith Norwich	1989–2003	Varley, Miss Eleanor D. Lowestoft	1946–53
Thirkettle, Frank (w) Headingley	1893–8	Veale, Miss Edith A. (w) Mundesley	1910–27
Thomas, Shirley Mulbarton	1998	Vickers, Pamela (c) Thorpe	1997–2003
Thompson, Kevin Lowestoft	1994–2002	Vigers, Frederick (w) Reedham	1926
Thompson, Patricia Norwich	1987–88	Villiers-Stuart, Mrs C.M. Beachamwell	1908–12
Thomson, Miss I.B. Heacham	1937–8	Vince, Stephen East Dereham	1989–90
Thorne, Mike (c) Wymondham	1982–89	Vining, Mrs Irene Mary Lowestoft	1962
Thorne, Ronald H. (c) Hethersett	1980–97	Vining, Dr Roy M. Lowestoft	1961–2
Thornhill, Miss Emma Geldeston	1908–13		
Thorp, G.L. Norwich	1936–8	Wade, Cynthia (c) Old Catton	1996–2003
Thorp, Mrs G.L. Norwich	1931–7	Waldron, Revd Herbert Norwich	1947–50
Tillott, Miss H.C. Blakeney	1938	Wales, Geoffrey (c) Norwich	1953–64
Tindal, Mrs Doris Verity Sheringham	1954–5	Walker, Gillian Norwich	1991–99
Torrey, Miss Susan Heacham	1936–47	Walker, Revd J.G. Beccles; Northampton	1933–6
Towle, Miss Audrey D. Hemsby; Lingwood	1965–95	Walker, Leonard London	1934–48
Townsend, Mrs M (w) London	1924	Walker, S. Scole	1936–46
Travers, Howard M. Norwich	1904–5	Walker, Stephen Roydon; Palgrave	1948–53
Traynier, Miss Barbara Belton	1931–2	Walker, Sydney Watkin Norwich	1957–64
Trim, Mrs Marion (c) Norwich	1972–86	Wallace, Miss Doreen Wortham	1956–7
Troke, S.J. Hemsby	1955	Waller, Revd Arthur H. N. Frostenden	1948–9
Trower, Heather Bramerton	1994–95	Waller, Canon Arthur Pretyman Waldringfield	1947–53
Trudgill, John (c) New Catton; Thorpe	1937–84	Waller, Bertram C. E. (w) Norwich	1905
Tuck, Horace W. (cw) Norwich; Sheringham	1904–52	Walpole, G. Holt	1931
Tull, Mrs P.M. Sheringham	1946–7	Walpole, J. Holt	1930
Turner, Miss Margaret G. (w) Sheringham	1929–37	Walters, Mrs Norwich	1899
Tuthill, Miss B.N. Fakenham	1901–3	Walton, F.W. Mattishall	1930

Walton, Sydney High Kelling	1958–69	Weinle, Frank Sprowston	1977–8
Ward, Derek Norwich	1948–55	Weinle, Trevor Norwich	1979–82
Ward, Gordon North Walsham	1951–2	Weiss, Mrs Shirley Carleton Rode	1961
Warner, Dr Howard (c) Beccles	1936–47	Welch, Kathleen M. (c) Norwich	1977–87
Warner, Zheni D. Norwich	1977–8	Welch, Rt. Revd William N. Norwich	1977–9
Warren, E. Allen London; Norwich	1926–31	Wells, Miss Helen A. Bracondale	1885–93
Warren, Jack Tatton Norwich	1932–52	Weston, Elizabeth (Mrs Starksfield) Norwich	1981–86
Waterfield, Miss Philida Attlebridge	1931	Weston, Arthur H. (w) Norwich	1893–1913
Waterfield, Mrs Winifred – see Buxton, Miss Winifred		Weyer, W.R. (w)	1896
Waters, Joan Shoil Burnham Market	1978	Whalen, Miss J.L. Norwich	1946–7
Waters, Owen Acle	1951–7	Wharton, Miss Hildred A. Blakeney	1954–63
Watling, Walter Thomas (c) Norwich; Thorpe	1919–56 *	Whatman, Gordon Norwich	1950
Watson, Charles J. (c) Norwich; London	1885–1928 *	White, Harry Bunwell	1976–7
Watson, Harold Norwich	1963–5	White, Mrs Mildred Constance Bunwell	1973–7
Watson, James Fletcher (c) Wicklewood; Norwich	1946–59	White, Rosemary Norwich	1988–89
Watson, John Old Catton	1990	Whittley, Malcolm Thetford	1986
Watson, Miss M. (w)	1894–5	Whitworth, Mrs Grace Norwich	1959–60
Watt, Mary Edgefield	1990–94	Whytehead, Mrs C.M. Eaton	1932–8
Watts, Arthur H. (w) Great Yarmouth	1898–9	Whytehead, Miss Rachel L. Norwich; Lowestoft	1934–48
Watts, Brian (c) North Walsham	2000–02	Wigg, Charles Mayes (w) Cromer; Brundall; Barton Turf	1909–36
Watts, Victor Norwich	1991–92	Wigger, Brian Michael (c) Norwich	1973–92
Watts, Walter Costessey	1987–2001	Wilkes, Miss B.K. Norwich	1936
Watts, Walter S.A. Norwich	1948–51	Wilkinson, Miss Alice C. (w) Saxlingham	1926–7
Wearing, J.K. Norwich	1937	Williams, Ann Roff Lowestoft	1991
Wearing, Stanley John Norwich	1932–60 *	Williams, Colin Lowestoft	1991
Webb-Bowen, Evelyn Beccles	1972	Williams, Eric Norwich	1954
Webb-Bowen, Col. Mostyn Beccles	1967–72	Williams, Mary	1973
Webster, Arthur Norwich	1964–5	Williams, Oliver Sheringham	1902–9
Webster, Mrs Jean McCallum Walberswick	1965–78	Williamson, Mrs. Gladys I. Norwich; Lamas	1924–48
Webster, John Stuart Holt	1952–65	Williamson, Gordon Trunch	1957
Webster, Sydney L. Norwich	1930–31	Williamson, Miss Peggy Anne Lamas	1948–63

Williamson, Mrs W.W. (w) Norwich	1924–7	Woods, Miss Patricia Joan Beeston	1959–68 *
Willins, E. Preston Norwich	1885–9	Woodward, Mrs (w)	1893
Willins, Miss M. Overstrand	1933–5	Woodward, Miss Alice Bolingbroke London	1887–1917
Willoughby-King, Ann Stalham	1990–92	Woodward, Miss Mary London	1893–8
Wilson, Mrs Anne (c) Barton Turf	1975–2003	Woodward, Sheila Norwich	2002
Wilson, Miss Bessie (w) Colney	1906–36	Woolbright, Miss (w)	1894
Wilson, D.A. Wynne (w) Norwich	1926–7	Wright, Charles Alwyn Marsham	1958–9
Wilson, Geoffrey Raveningham; Gainsborough; Haddiscoe	1957–68	Wright, C.O. Bishops Stortford	1937
Wilson, H.L. Norwich	1887	Wright, Miss Marjory (w) Norwich	1898–1903
Wilson, Revd Herbert Mulbarton	1896	Wright, Sally J. Sprowston	1982–87
Wilson, Miss J. Norwich	1888–9	Wright Miss Vera New Catton; Runhall	1909–33
Wilson, Robert E. (c) Royston; Barton Turf	1971–2003	Wrigley, Thomas (w)	1927
Wilson, Mrs S.A. Saxlingham Nethergate	1932–6		
Wimpenny, Mrs Helen M. St Olaves	1962–6	Yallop. Doreen Hellesdon	1986–92
Winner, Catherine New Costessey	1976	Yelf, H.F. Norwich	1887–93
Winsworth, F.E. Sprowston	1946	Young, Mrs Hilton (w)	1923
Winter, Alexander Charles (c) East Rudham; Brancaster	1946–53	Young, Joan Coltishall	1983–4
Winter, Miss Katharine Swaffham	1904–22	Young, Dr John F. Norwich	1970–4
Winter, W. Tatton (w) Reigate	1898–1902	Young, Richard (c) Norwich	1975–89
Winterton, William King's Lynn	1947	Young, Miss Sibyl Hunstanton	1930–37
Wintour, Miss (w) Barnsley	1905	Youngs, Laurence London	1886–91
Wiseman, Miss Gertrude (w) Great Yarmouth	1898	Youngs, Percy James Norwich	1947–64
Wood, S.E. Hamilton (c) Norwich	1947–70	Youngson, Miss Belinda North Walsham	1938–50
Wood, Wilfred R. (w) Hethersett; Brandon	1886–92	Youngson, Miss Rowena Mary (c) North Walsham	1934–56
Woods, Mrs Elsie Beeston	1951–73		
Woods, Michael Norwich; Godalming	1951–63	Zucker, Miss Elizabeth Norwich	1968–72

Officers of the Norfolk and Norwich Art Circle 1885–2003

Presidents

1885	Charles John Watson
1888–98	Henry George Barwell
1899–1924	Robert Bagge Scott
1925–27	Geoffrey Birkbeck
1928–31	Arnesby Brown
	Geoffrey Birkbeck – Acting President Art Section
	Nugent Monck – Acting President Literary Section
1932–34	Alfred Munnings
1935–37	Arnesby Brown
1938	Geoffrey Birkbeck
1974–76	Noel Spencer
1977–79	Raymond H. Banger
1980–81	Mrs Mildred Faulkner
1982–85	Tom Griffiths
1986–88	Henry J. Starling
1989–91	Michael B. Everitt
1992–94	Mrs Joan Banger
1995–97	Miss Delphine Dickson
1998–2000	Miss Irene Ogden
2001–03	Mrs Iris Francis

Vice-Presidents

1885–87	Robert Bagge Scott
1888–93	J. Miller Marshall
1894–98	Robert Bagge Scott
1899–1901	Leonard G. Bolingbroke
1902–4	Sidney Felix Howitt
1905–8	Leonard G. Bolingbroke
1909–19	T.J. Scott
1920–23	Charles W. Hobbis
1924–25	Charles W. Hobbis
	Horace William Tuck
1926–27	F. Jane Bayfield
	Aubrey A. Blake
	Leonard G. Bolingbroke
	Charles W. Hobbis
	Horace William Tuck
1981	Henley G. Curl
	Tom Griffiths
	Noel Dennes
1982–85	Henley G. Curl
	Noel Dennes
1991–2003	Raymond .H. Banger
1991–96	Henry. J. Starling
1992–2003	Michael B. Everitt
1995–2003	Mrs Joan Banger

Chairmen

1932	Horace W. Tuck		1976	Miss Anne Cook
1933	Ernest A. Curl		1977	Tom Griffiths
1934	Mrs Winifred Waterfield		1978	Dr John Leslie
1935	Walter Thomas Watling		1979	Richard Young
1936	The Hon. Mrs Carruthers		1980	Mrs Anne Wilson
1937	Horace W. Tuck		1981	Mrs Mary Barnard
1938–39	Mrs Diana Hamond		1982	Miss Irene Ogden
1939–40	Dr Howard Warner		1983	Gareth Hawker
1940–41	Mrs Nell G. Dickson		1984	Mrs Iris Francis
1941–45	Mrs Winifred Waterfield		1985	Michael B. Everitt
1945–47	Ernest A. Curl		1986	Miss Delphine Dickson
1947–49	H. James Starling		1987	Miss Judy Hines
1949–50	Mrs Nell G. Dickson		1988	Ron Thorne
1951–52	Henley G. Curl		1989	Mrs Dorothy Mindham
1953–54	Wilfred S. Pettitt		1990	Mrs Anne Wilson
1955–56	Noel Spencer		1991	Miss Irene Ogden
1957–58	Tom Griffiths		1992	David Talks
1959–60	Mrs Vera Spencer		1993	Miss Delphine Dickson
1961–62	Noel Dennes		1994	Anthony Dalton
1963–64	Edward S. Hines		1995	Robert Wilson
1965–66	Peter Arnold		1996	Bernard Keath
1967–68	S.E. Hamilton Wood		1997	Ted Geeson
1969	Mrs Mildred Faulkner		1998	Bernard Keath
1970	Michael B. Everitt		1999	Mrs Anne Wilson
1971	Albert Booth Ogden		2000–01	Robert Wilson
1972	Ronald Courteney		2002	Brian J.S. Watts
1973	Mrs Joan R. Banger		2003	Miss Adrienne May
1974	Derek Hutchinson			
1975	Ronald Crampton			

Vice-Chairmen

1937–48	Ernest A. Curl
1949–50	H. James Starling
1951–52	Mrs Nell G. Dickson
1957–58	Noel Spencer
1961–62	Mrs Vera Spencer
1963–64	Noel Dennes
1965	Edward S. Hines
1966	S.E. Hamilton Wood
1967–68	Mrs Mildred Faulkner
1969	Michael B. Everitt
1970	Albert Booth Ogden
1971	Allan Laycock
1972–73	Mrs Joan R. Banger
1973	Derek Hutchinson
1974	Ronald Crampton
1975	Miss Anne Cook
1976	Tom Griffiths
1977	Dr John Leslie
1978	Richard Young
1979	Mrs Anne Wilson
1980	Mrs Mary Barnard
1981	Miss Irene Ogden
1982	Gareth Hawker
1983	Mrs Iris Francis
1984	Michael B. Everitt
1985	Miss Delphine Dickson
1986	Miss Judy Hines
1987	Ron Thorne
1988	Mrs Dorothy Mindham

1989	Mrs Anne Wilson
1990	Miss Irene Ogden
1991	David Talks
1992	Miss Delphine Dickson
1993	Anthony Dalton
1994	Robert Wilson
1995	Bernard Keath
1996	Ted Geeson
1997	Not elected
1998	Chris Blanchard
1999	Mrs Cynthia Wade
2000	Mrs Maura Mould
2001	Michael Sullivan
2002	Miss Adrienne May
2003	Mrs Janet Harrison

Honorary Secretaries

1885–92	Leonard G. Bolingbroke
1892–95	Charles Clowes
1895–1924	Geoffrey Birkbeck
1925–26	Miss Georgina Offord
1926	Mrs Violet Clutterbuck
1927	Mrs Violet Clutterbuck
	J. Gordon Dodson
1928	J. Gordon Dodson
1928	Owen P. Smyth
1929–31	J. Gordon Dodson
1932–45	C.L. Lowe
1945–46	Horace William Tuck

1946–48	Wilfred S. Pettitt
1949–58	Mrs B.H. Pettitt
1959–64	Miss Elsie Carrick
1965–69	Mrs A.B. Ogden
1970–76	Raymond H. Banger
1977	Mrs Kathleen J. Barnard
1978	Mrs M.R. Mayhew
1979–85	Raymond H. Banger
1986–96	Mrs Gloria Fagg
1997	Mrs Margaret Geeson
1998	Not elected
1999	Mrs Maura Mould
2000–01	Mrs Thelma Shaw
2002	Mrs Janet Harrison (act.)
2003	Brian J.S. Watts

1945–50	Henley G. Curl
1951–77	Frank Beeton Nichols
1978–81	Robert E. Wilson
1982–86	Horace Rycraft
1987–92	Raymond H. Banger
1993–2001	Keith Thickett
2002–03	Raymond H. Banger

Honorary Treasurers

1885	Henry George Barwell
1888–91	Charles Clowes
1892–94	George O. Clark
1895–98	Leonard G. Bolingbroke
1899–1924	Geoffrey Birkbeck
1926–30	Fred Russell, Subscription Secretary
1931	K.B. Riches
1932–33	J. Gordon Dodson
1934–45	C.L. Lowe, Treasurer & Secretary

Honorary Life Members

1925	Miss N. Bagge Scott
1946	Horace William Tuck
1948	Ernest A. Curl
1951	Miss G.V. Barnard
1975	Noel Spencer
1978	George Butcher,
	Frank Beeton Nichols
1979	Raymond H. Banger
1982	Tom Griffiths
1984	Miss F. Maidie Buckingham
1986	Miss S.O. Lascelles,
	Miss M. Porter
	N. Dennis
	H. Curl
1987	Mrs J. Paine
1988	Miss B. Fugl
2000	Mrs G. Fagg

Page Index of Artists' Biographies and Illustrations in alphabetical order